U0164848

短歌行

吳建斌

A Ballad

Wu Jinbin

翌藝文舍
Photo At

緣起

六年前，五一假期過後，我從香港來到了上海，有朋友告訴我，楊浦區老弄堂的動遷已經進入了倒計時，若要想拍，就要抓緊去拍。於是，我把工作和生活安頓妥當後，立即投入到拍攝楊浦區的老弄堂之旅。

一

150 年前，上海尚是一個小縣城，隨著工業落地黃浦江、松江一帶，經濟開始起飛，於是周邊的弄堂逐漸紅紅火火，熱鬧非凡。有人統計過，解放前夕上海老弄堂有 3840 條，2000 年剩下 2560 條，2013 年銳減到 1490 條，其銳減的主要原因是城市發展擴容的結果。

眼下，楊浦區的老弄堂分佈在楊浦大橋兩邊，也就剩下幾十處了。為了能留下老弄堂最後的影像，每個週末，無論何種天氣，我都會走入老弄堂。四年下來，我為積攢了海量的老弄堂影像資料感到無比欣慰。

上海「弄堂」一說興於晚清，裏面的建築風格和人文景象呈中西融合之態。

近百年來，楊浦區的老弄堂是伴隨著工業和大學興建而建起來的。這裏是中國現代工業的發祥地，是中國早期大學的彙聚地。

楊浦區八埭頭一帶的老弄堂，始建於清光緒 34 年，磚木結構，至今已有 100 多年歷史。

隆昌公寓老弄堂建於 1920 年到 1930 年之間，由英國人設計。

杭州路與楊樹浦路交匯處有幾排紅色外立面的老房子，是日本人在 1920 年前後設計並建造的。

福寧路 99 弄建於 1930 年，是日商上海大純紗廠一線管理人員及工人的住宅區。弄堂佔地面積不大，每一排有 10 戶，共 80 戶。1936 年，作家夏衍在這裏完成了他的小說《包身工》。

照片是記錄歷史最為重要的載體之一。

當我走進這些老弄堂，舉起相機，聽著發生在老弄堂裏的故事，我的情感也很快融進了這充滿煙火氣的狹小的空間裏。

有幾位90多歲高齡的老奶奶，她們開朗、健談、自信、從容，目光炯炯有神，給我留下了極深的印象，他們在這些弄堂裏住了一輩子，現如今唯一訴求是期待在有生之年能住上有電梯的房子。每次去都會向他們探尋這弄堂裏的故事，我除了熱愛攝影還被冠之作家的身份，搜集各種素材也成了我的習慣。

二

記得我初次走進老弄堂，感覺到裏面是雜亂無章、烏煙瘴氣，當去多了，能感覺到鑲嵌在這裏的很多生活習慣是有秩序的，每件事都有人管。

老弄堂裏的房子大多是三層高、連體樓為主，頂有天窗，俗稱「老虎窗」。

很多時候走到樓棟門口，以為是一個普通門棟。可當走入裏面，會發現大有乾坤，突然像走入一個與現代化無關的久遠的生活空間。同樣是小空間，有的人家把家裏收拾得井然有序，可有人把家裏搞得無處下腳。

一般而言，老弄堂地面一層的每家每戶都會把門口充分利用起來，家家戶戶有一個水龍頭和大水槽，可用來洗菜、洗衣服。條件許可的話，還會隔出一塊小地方當作廚房。有的人用盡家裏一切空間，能在狹小的空間裏再辟出一個小小馬桶間；沒有條件的，會在臥室放一個馬桶。

每天清晨，到老弄堂公用固定的地方排隊沖洗馬桶是一道風景線，鄰里們排著隊，互諒互讓，好有禮貌。

夜幕降臨，淡淡的燈光從密密麻麻的窗戶裏斜射出來，光線落地對面的牆壁上或狹窄的通道上，有人坐在外面納涼，有人穿著睡衣、戴著老花鏡在路燈下讀報紙，還有男男女女的老人紮堆聊天，很有生活情調。

其實，逝去的老弄堂早已成為上海這座高度現代化都市的一筆寶貴財富，是上海幾代人寄託的精神家園。因為拍攝，我對老弄堂裏的一草一木、一物一石都饒有興趣。有時候，我的身心會停留在一個不起眼物體上，靜靜地揣摩著它的過去、現在和未來。那一刻，我把自己當成一個藝術家，或哲學家或社會學家，尋找著富有厚度和寬度的生命意義的元素。

這一情一景之所以被凝固下來，盡在於那片刻間的情緒表達。

吳建斌
2022 年 6 月

Prelude

Six years ago, after the holidays of May Day, I left Hong Kong for Shanghai. I was told the old longtangs in Yangpu district would soon be demolished. Time was ticking. I had to seize the time to photograph them. Having my job and life settled, I set off my photographic journey along the old longtangs in Yangpu district right away.

I

150 years ago, Shanghai was just a small county. Only after industries flourished along the Whangpoo River and around Songjiang District, in a booming economy the neighbouring longtangs prospered. According to statistical data, there were 3840 longtangs in Shanghai before 1949. In 2000, 2560 were left and in 2013, only 1490. Their abrupt disappearance was a result of urban redevelopment.

In Yangpu District, only a dozen of old longtangs are left, scattering along the river banks near Yangpu Bridge. To preserve the last surviving images of longtangs, I was there every weekend in all weathers. Four years passed. It is gratifying to have collected a magnitude of the images of the old longtangs.

The Shanghainese term, longtang, is said to be originating from the late Qing dynasty. Its architectural styles and communal scenes exhibit the integration of Chinese and Western cultures.

In the past century, the old longtangs in Yangpu District had been constructed along with the founding of industries and universities. This was where modern industries and the earliest universities of China laid their foundations.

The construction of the longtangs surrounding Badaitou, Yangpu District commenced in the 34th year during the Guangxu Reign of the Qing Dynasty (1908). These brick and wood structures are over 100 years old.

Built between 1920 and 1930, longtangs around the Longchang Apartment were designed by the British.

At the intersection of Hangzhou Road and Yangshupu Road are several rows of old houses with red facades, designed and constructed by the Japanese around 1920.

Built in 1930, Lane 99, Funing Road, used to be the residential community of the managers and workers of the Japanese owned textile mill named Dachun. The small longtang accommodated 10 households in each row, 80 in total. In 1936, writer Xia Yan completed his novel *Indentured Labourer* there.

Photographs are one of the most important media to record history.

Setting foot in these longtangs, I raised the camera and listened to their stories. Soon I was immersed in the narrow yet cosy place.

I was deeply impressed by the 90–year–old ladies in whose bright eyes I saw their souls cheerful, expressive, confident and self–contented. Having lived in the longtangs for all their time, they wished there would be a home accessed with elevator. As a photography enthusiast and a writer, as they called me, I loved visiting the places to explore their stories, as if a habitual collecting process.

II

I remembered the first time in an old longtang, chaotic and filthy. But having familiarized myself there, I found the embedded orders behind many of those lifestyles and for each circumstance you could always find someone responsible.

Most houses are three–storey high, interconnected, with a dormer installed, the so called "tiger window".

Only by judging a gate, one may assume a house to be ordinary. But when one enters, he may find a secluded living space distanced from modernization. Despite their tiny size, some houses are neatly tidied while some so messed up that one can never set a foot in.

Commonly speaking, the front yard on the ground floor of an old longtang is fully utilised by each household. A water tap and a hug sink are placed for cooking and laundry. If the condition allows, a corner will be partitioned to be the kitchen. Some are desperate to make a partition for the toilet; if impossible, the toilet may be placed in the bedroom.

In early morning, there is a unique scene: residents lining up courteously one after one, for washing their toilet at the designated public area.

As dusk falls, lamps are lit, their glow scattering on the walls or the narrow passages through the crowded windows. Some enjoy the cool breezes outdoor; some read the news in their pyjamas and reading glasses; some chattering with one another. These are their lives.

The vanishing longtangs have long been a great treasure for such a highly modernised metropolis as Shanghai, the cultural homeland of generations. In the course of photography, I am drawn to each and every object in the old longtangs. Occasionally, I would connect with a forgotten object, contemplating its past, present and future. At that very moment, I see myself as an artist, a philosopher, or a sociologist, seeking the meaning of life in its depth and breadth.

A photograph captures each and every scene, composed of the sensations at that very moment.

Wu Jianbin
June 2022

　　弄堂也叫里弄，是上海所獨有的居住場所，亦是近代上海文化的重要組成部分。有人說，沒有弄堂就沒有上海，更沒有後來的上海人。

A longtang, also known as lilong, is a lane clustered with residential communities in Shanghai, a unique and indispensable part of modern Shanghainese culture. Some say, there is no Shanghai without longtang, let alone Shanghainese.

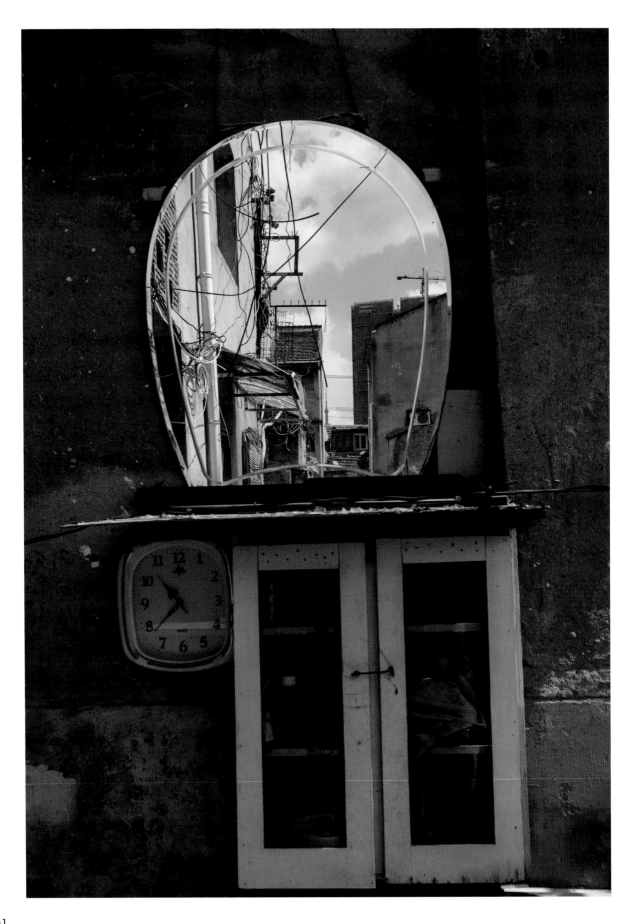

01

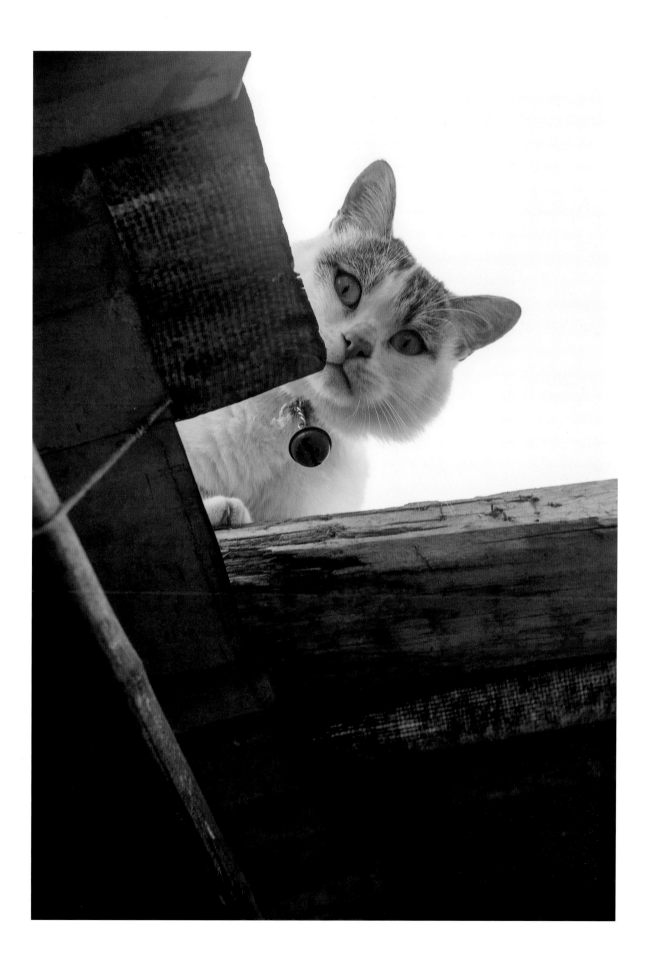

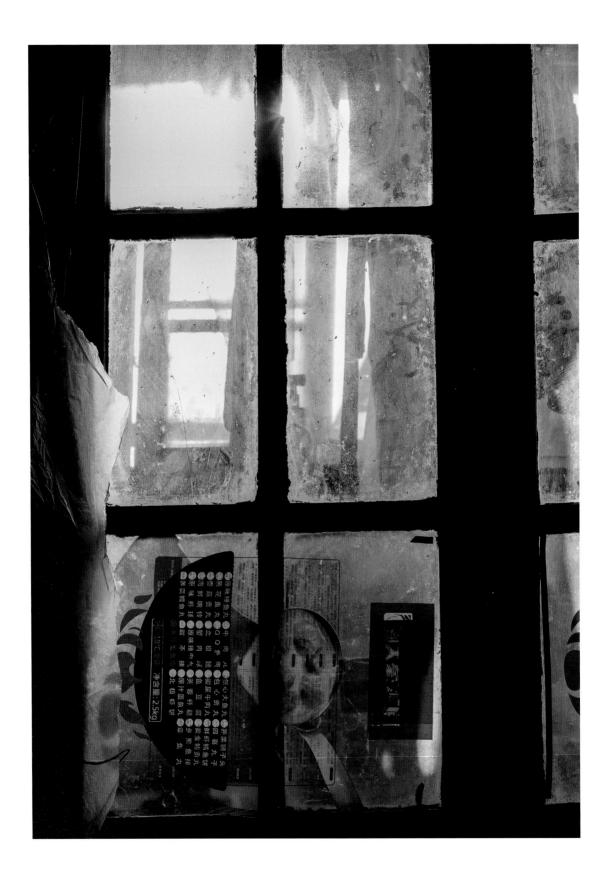

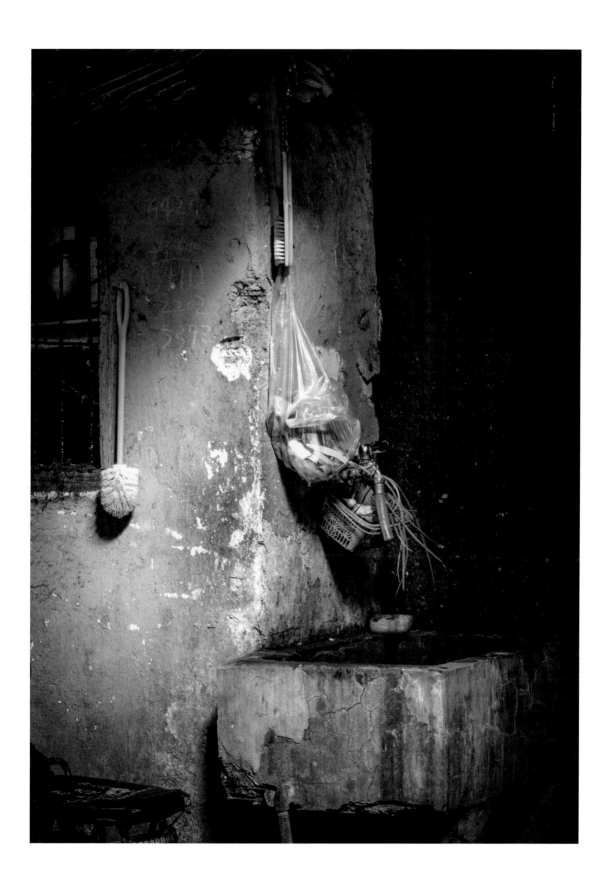

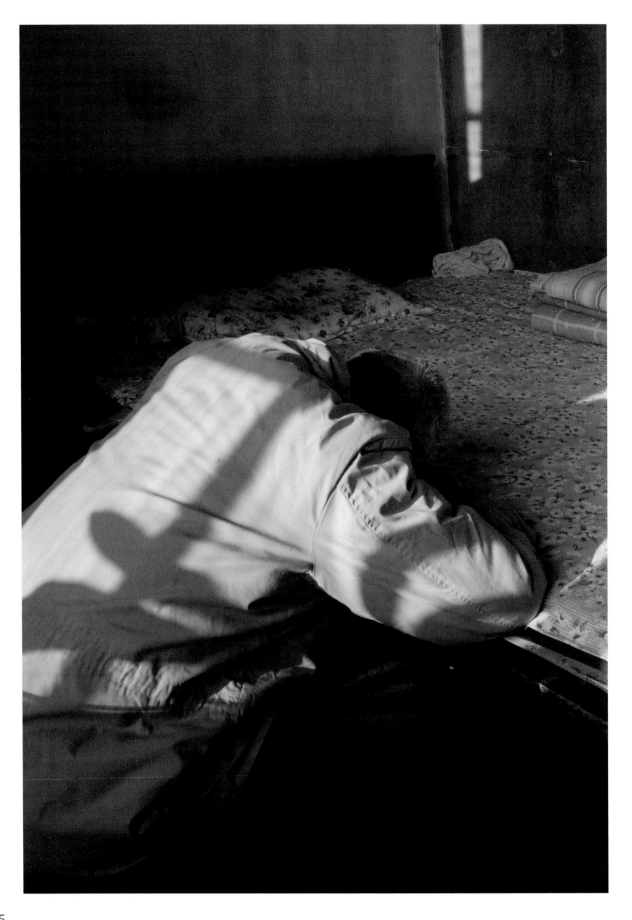

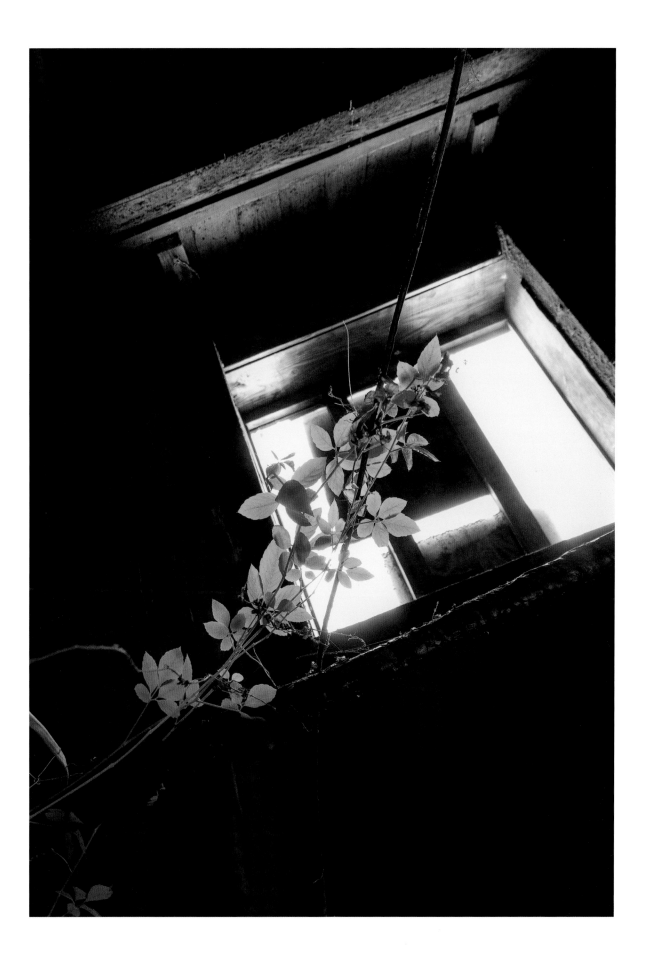

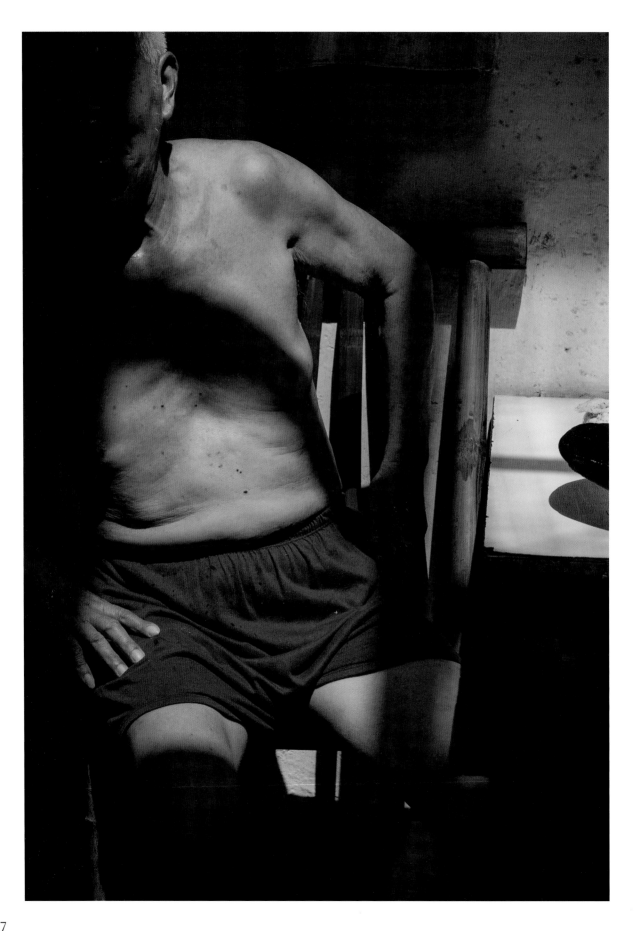

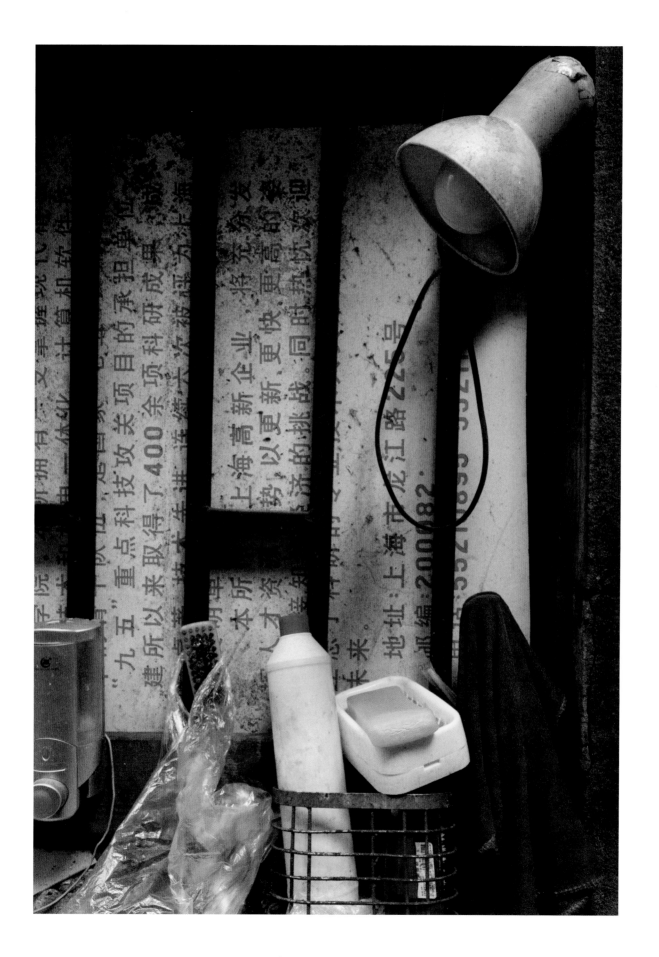

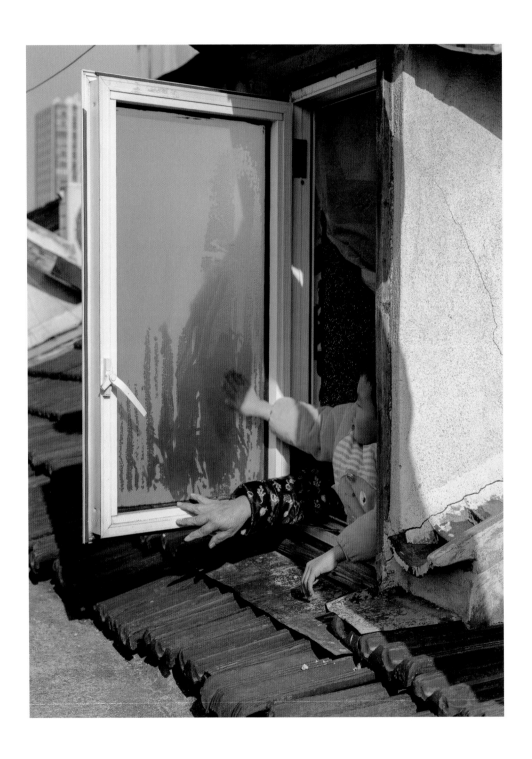

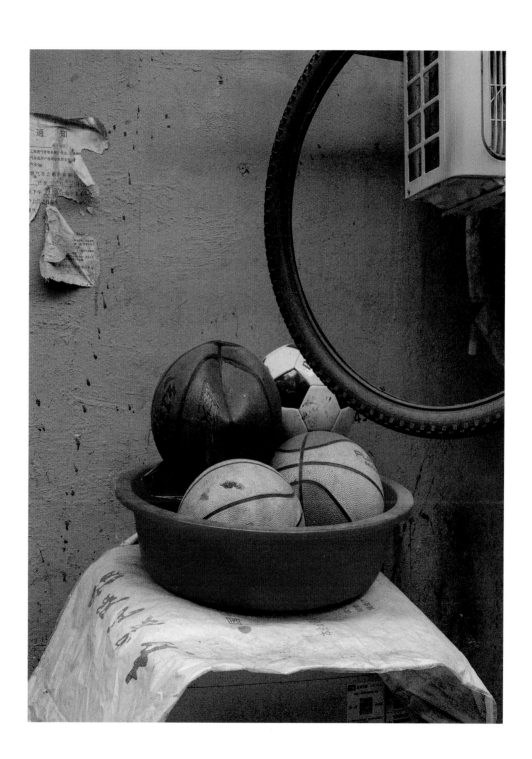

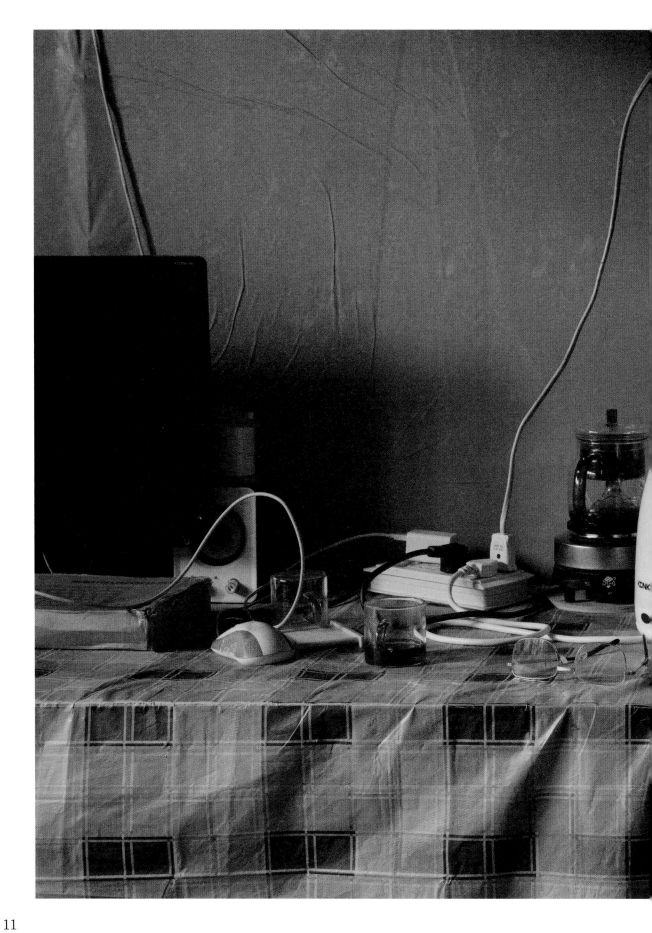

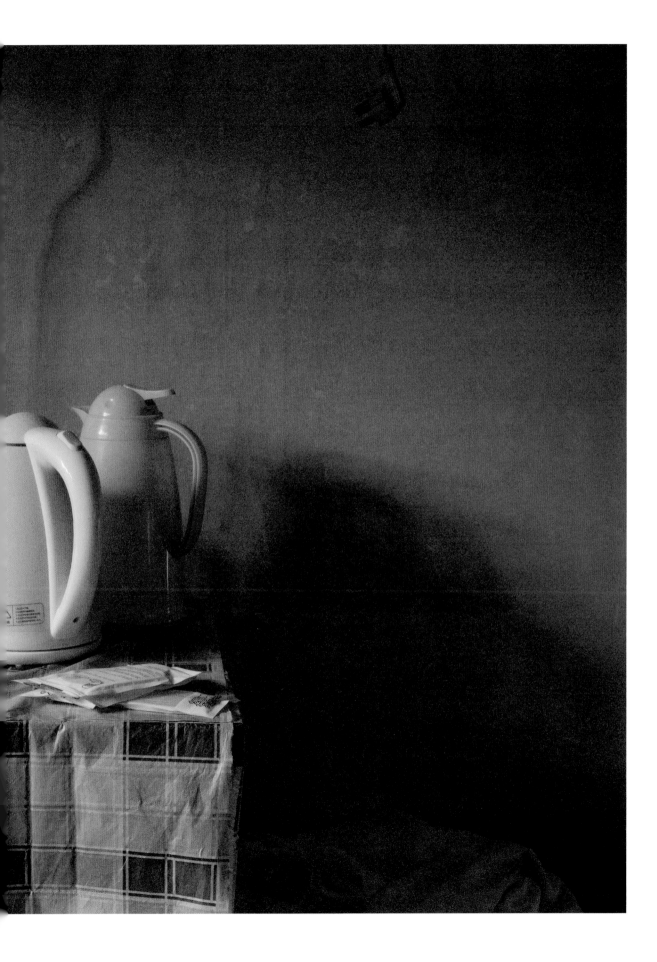

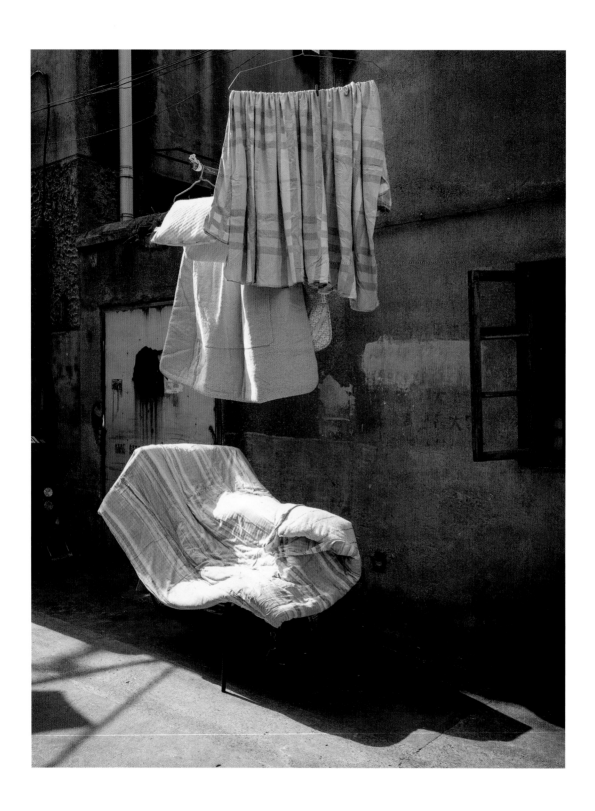

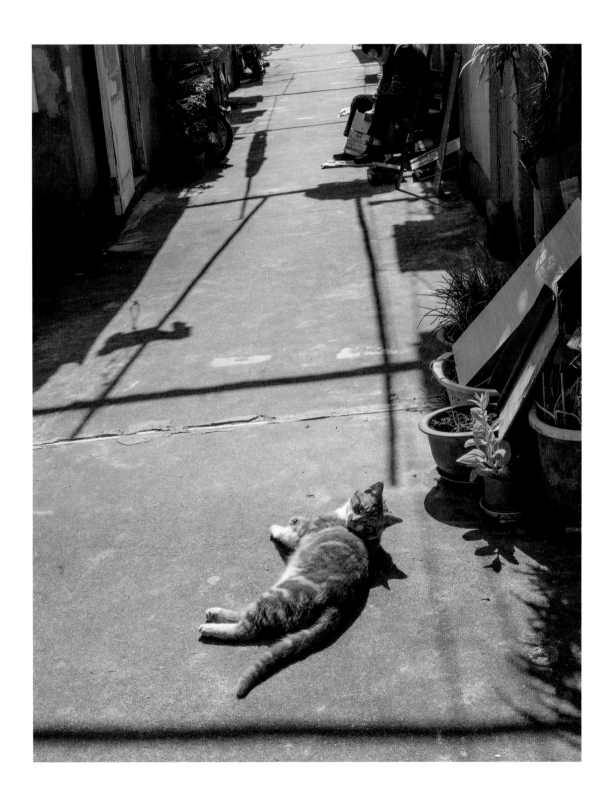

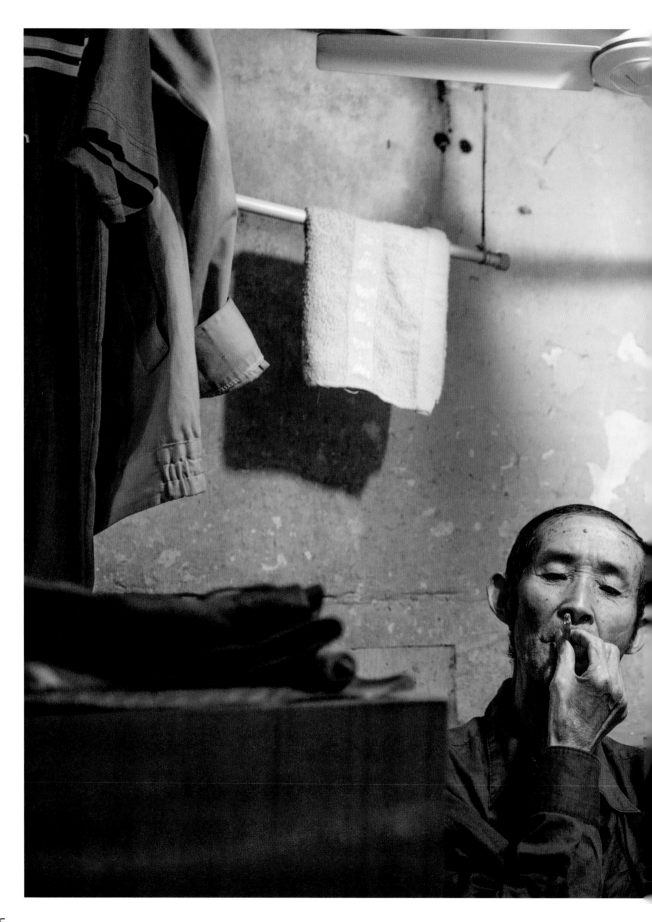

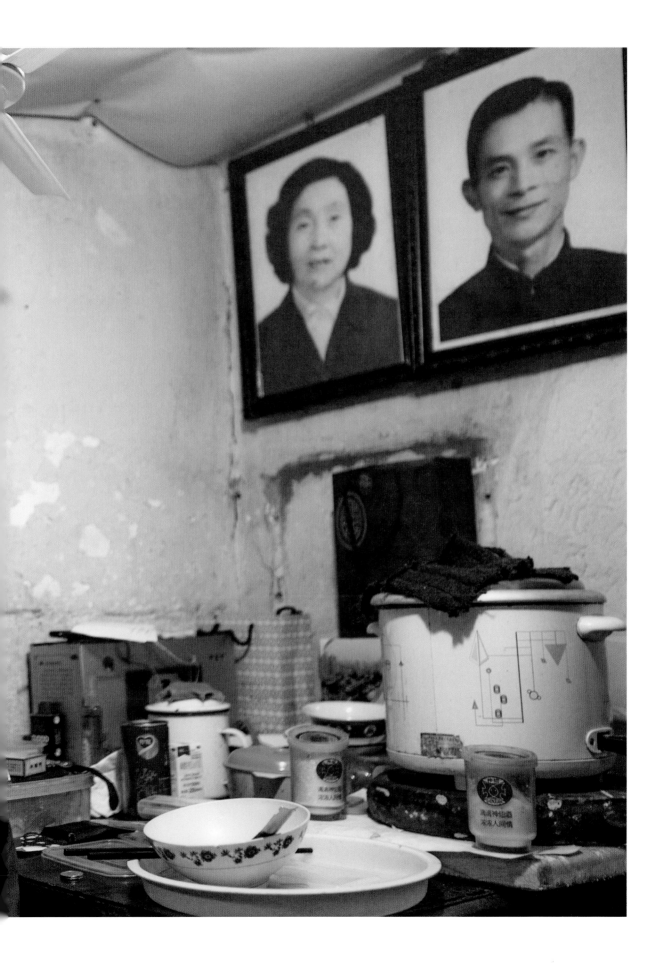

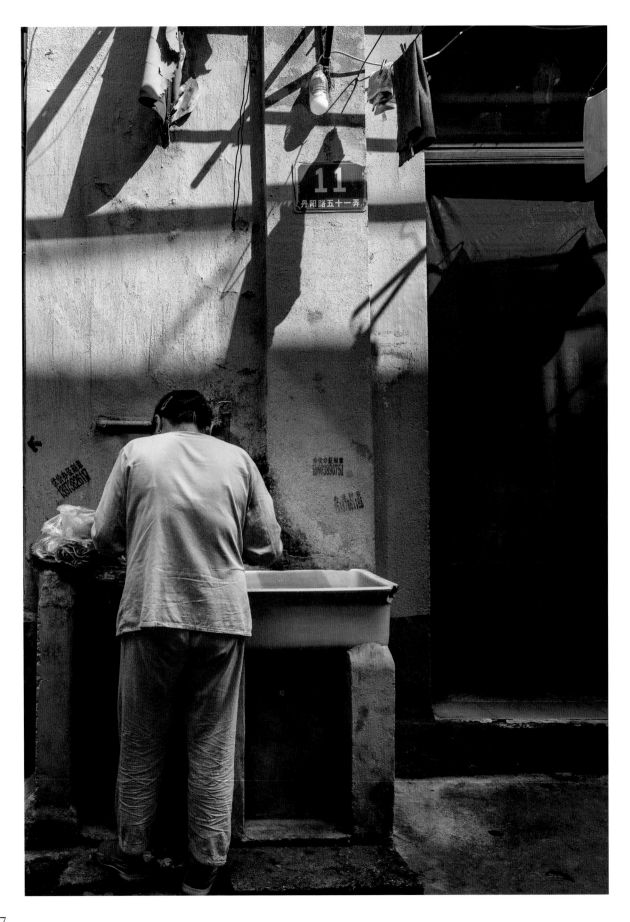

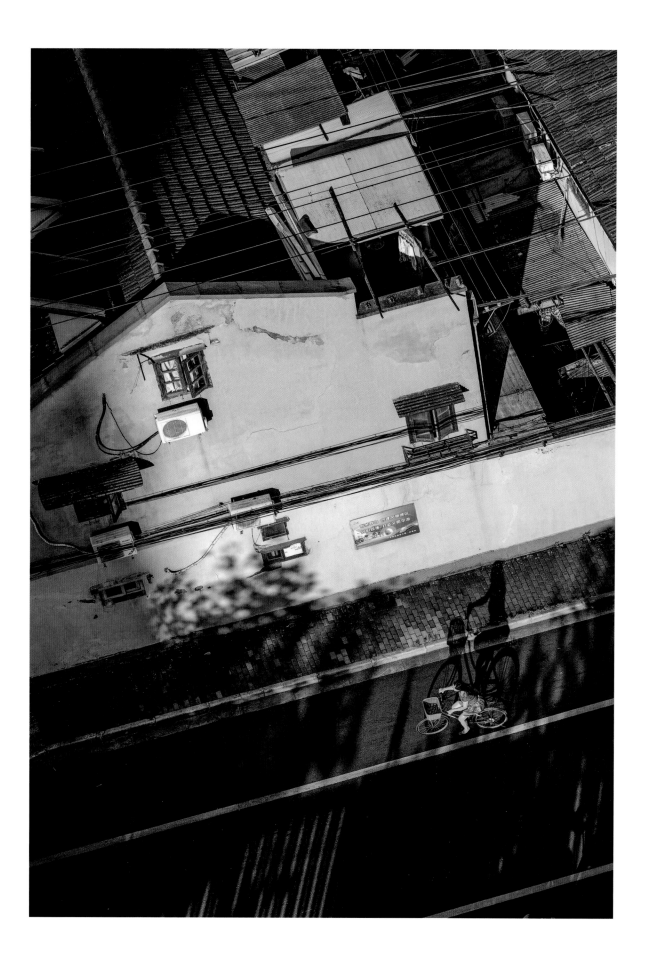

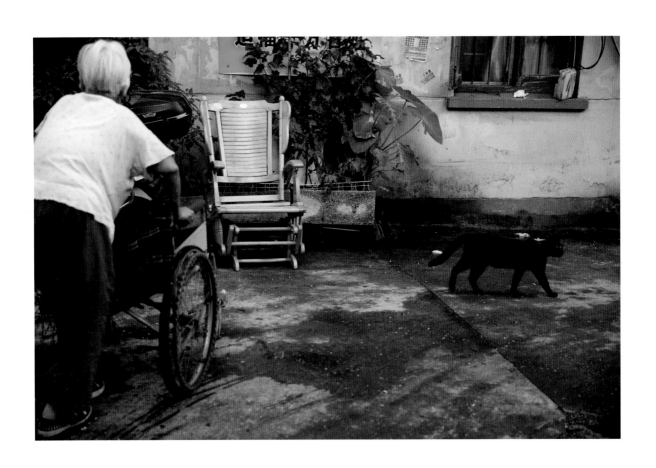

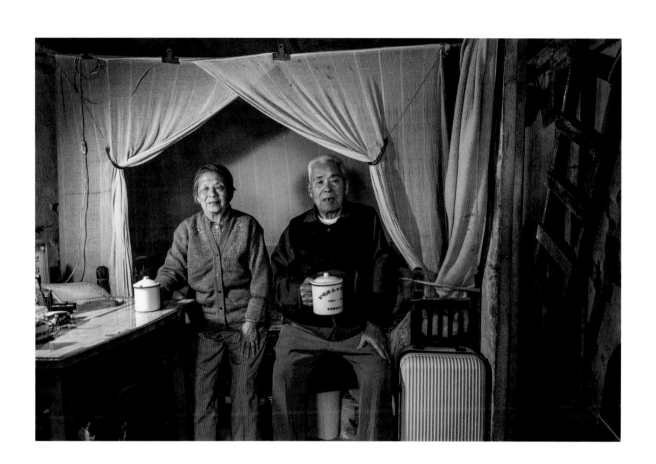

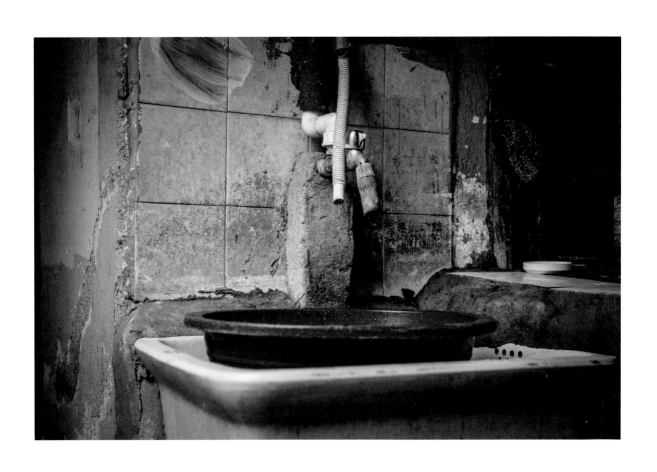

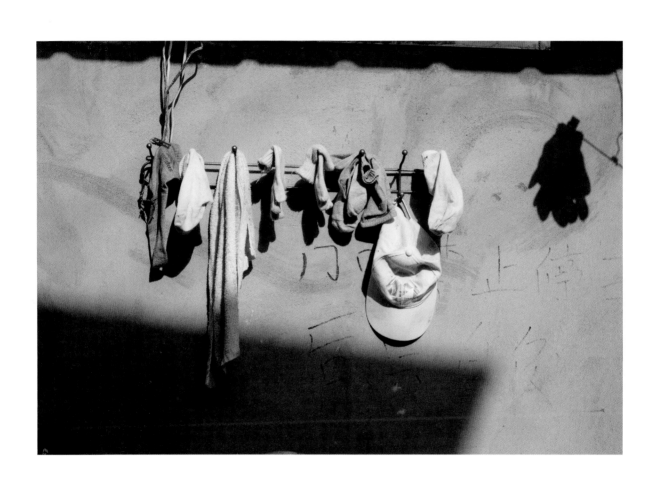

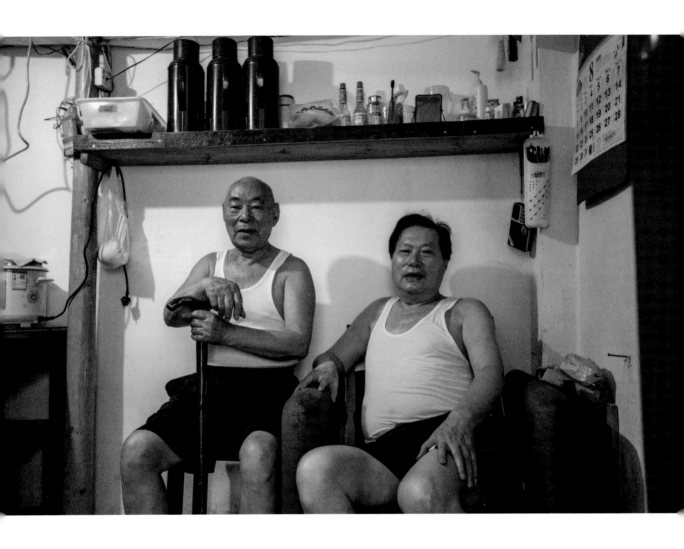

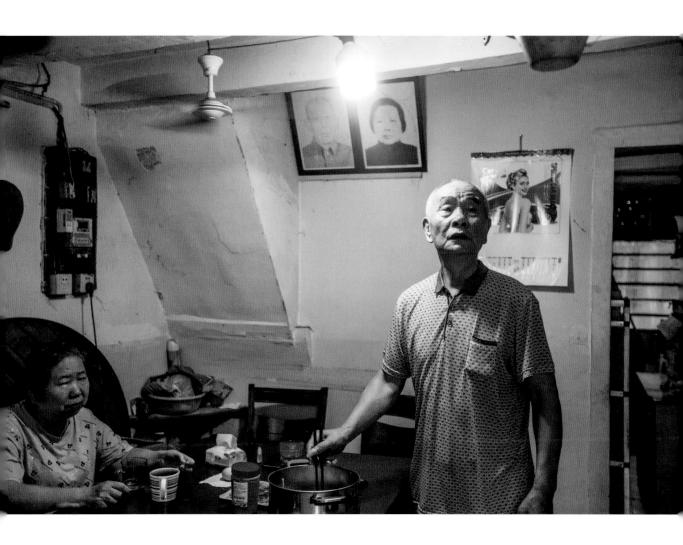

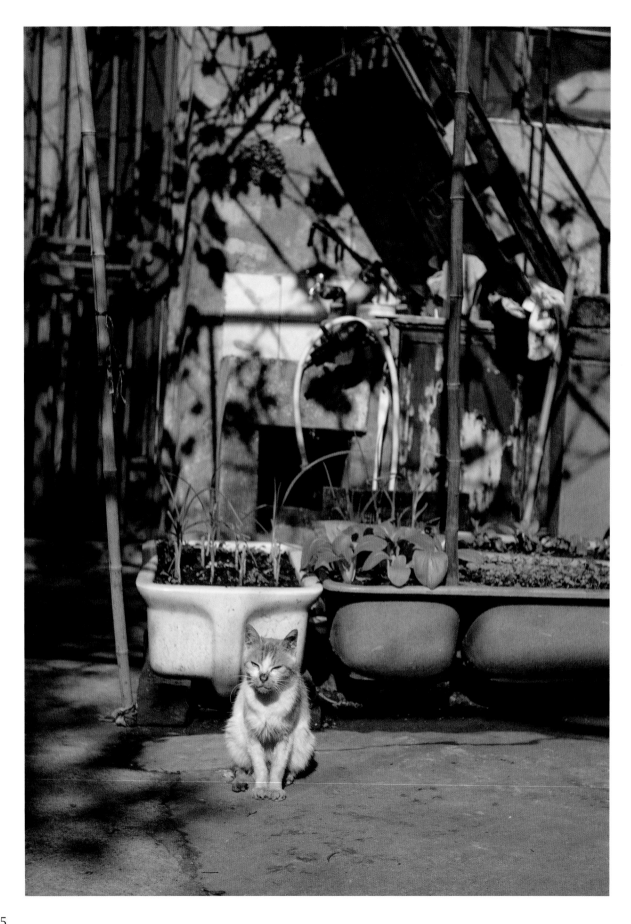

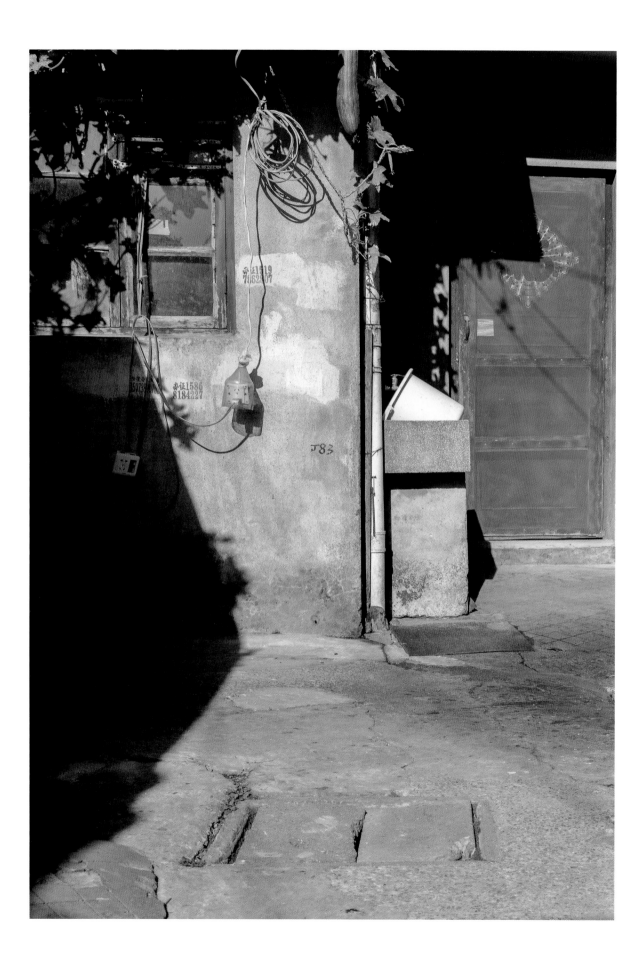

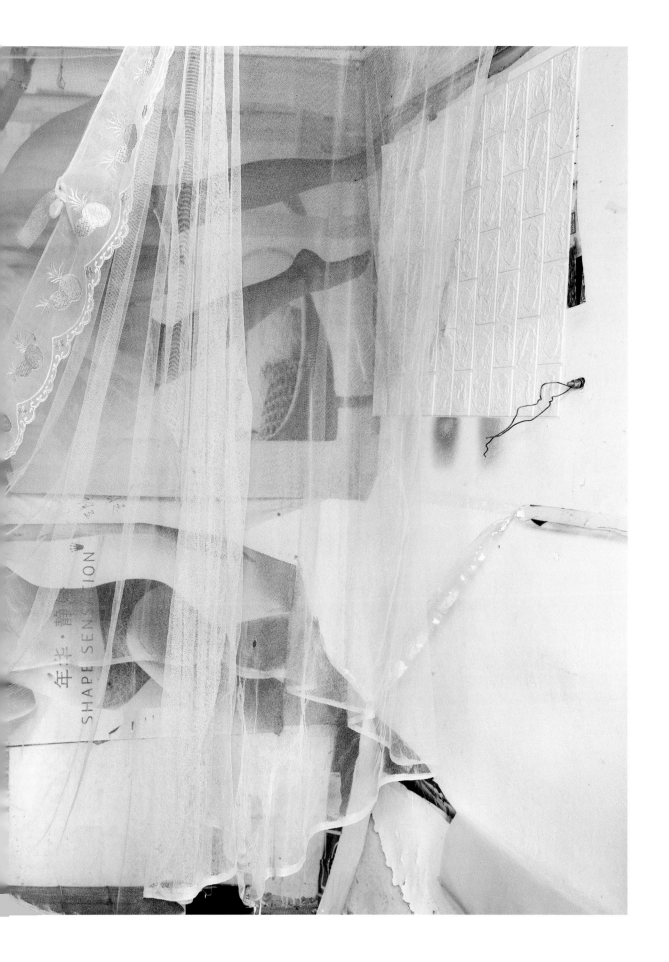

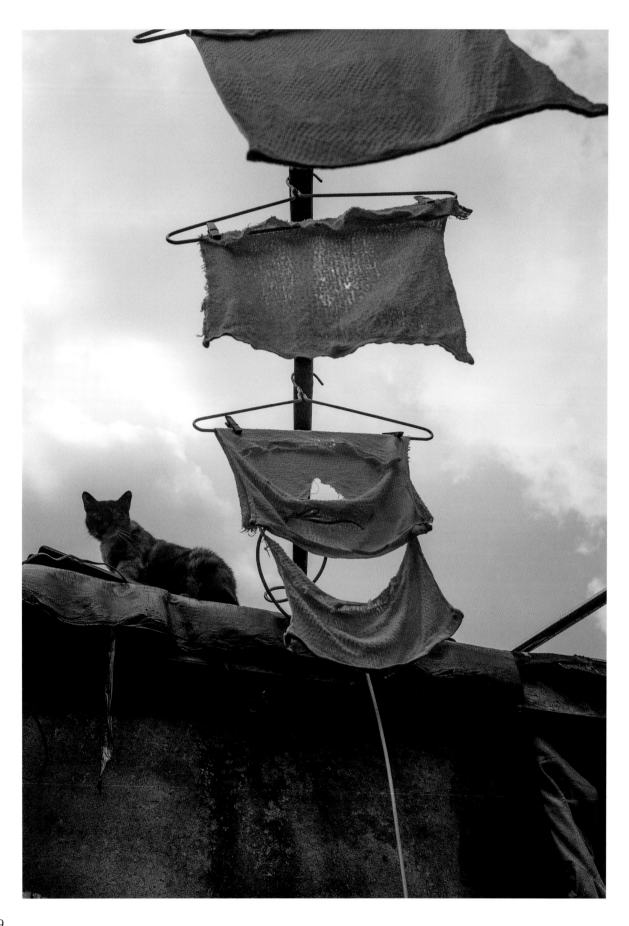

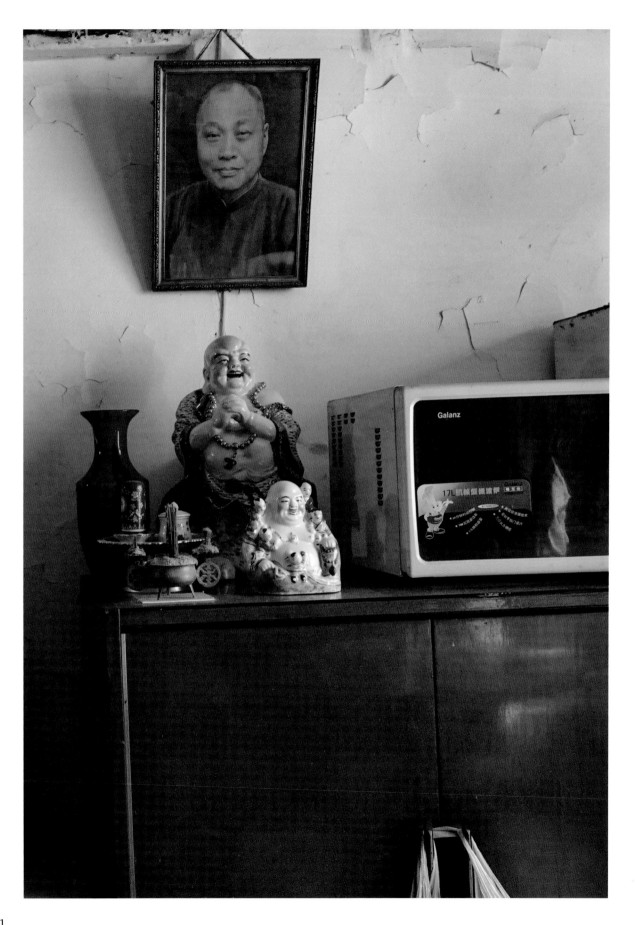

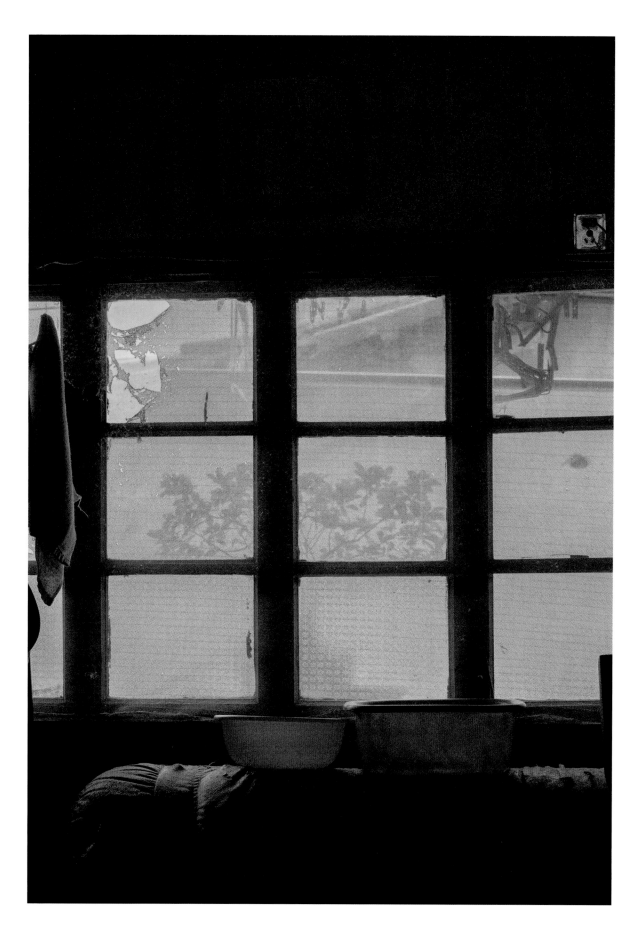

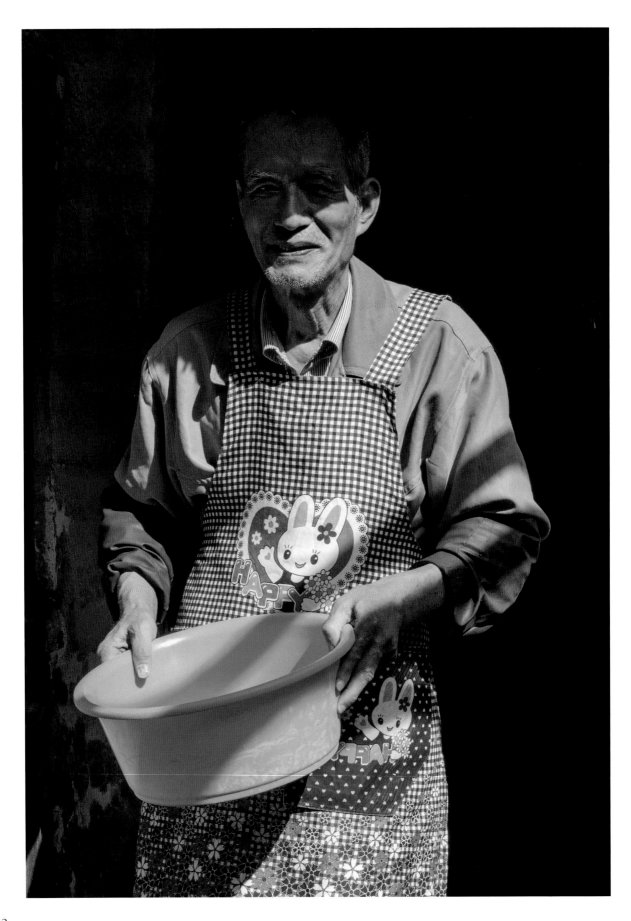

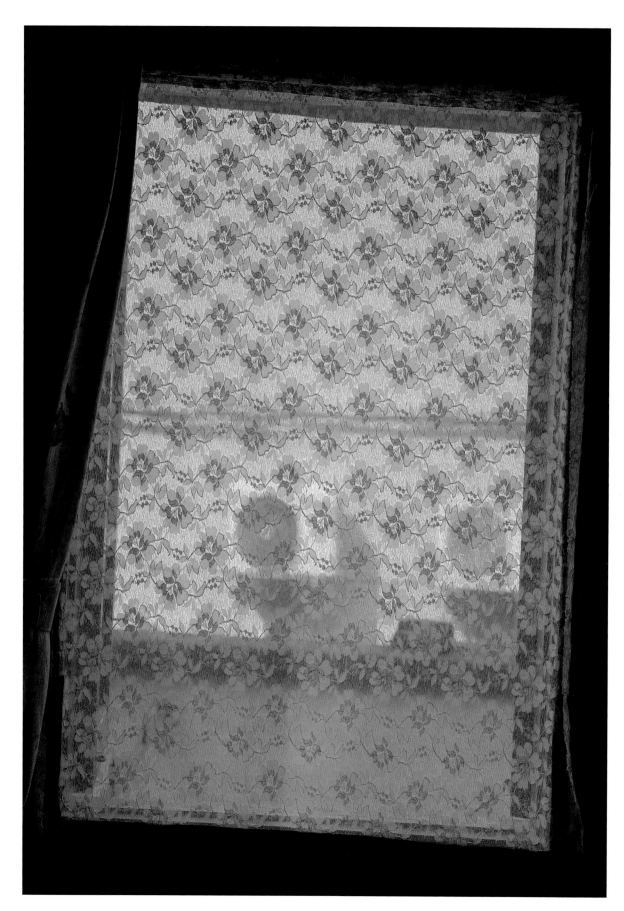

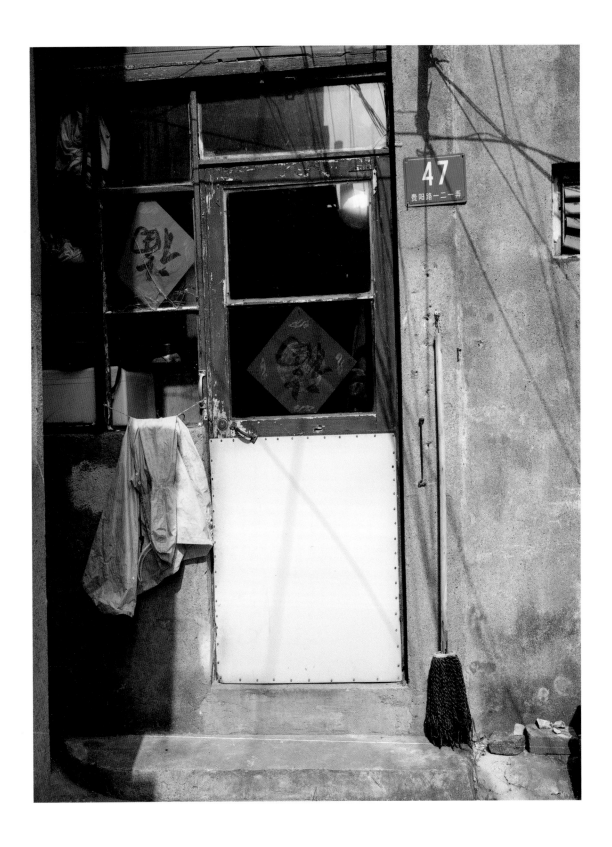

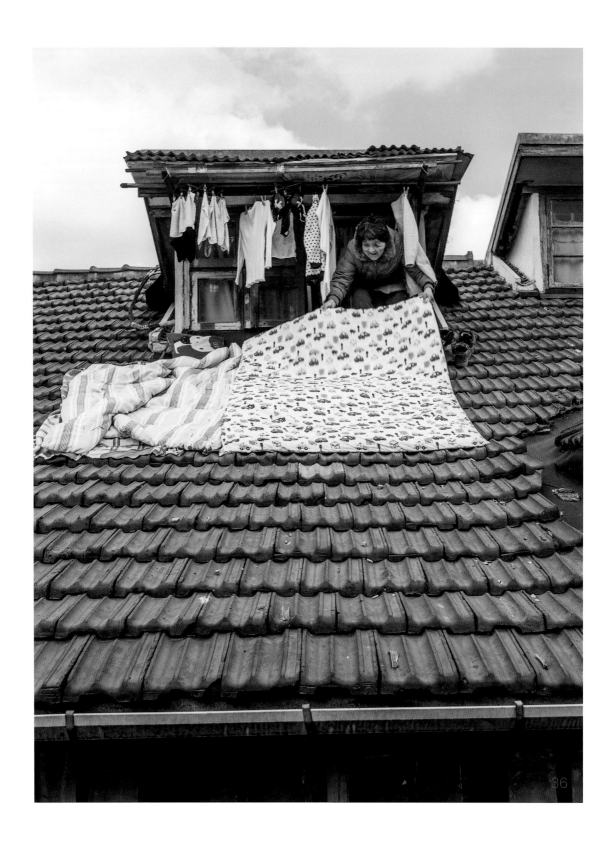

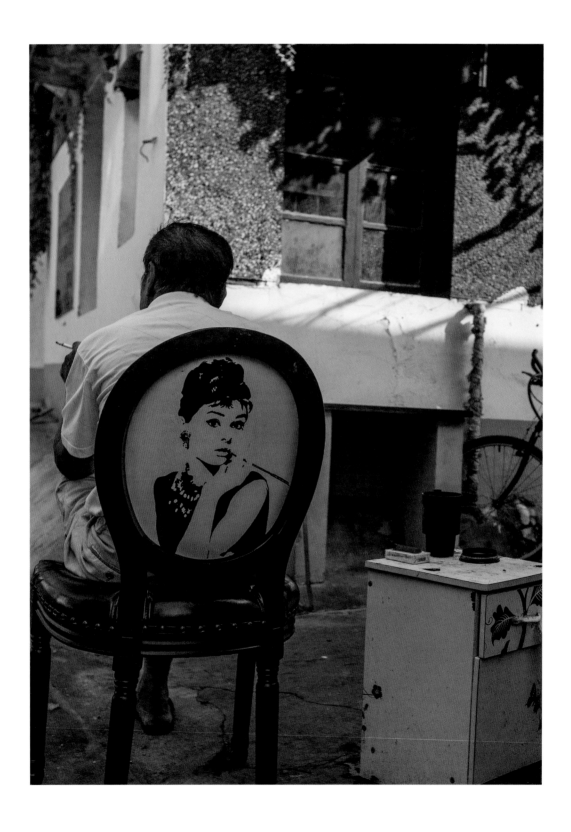

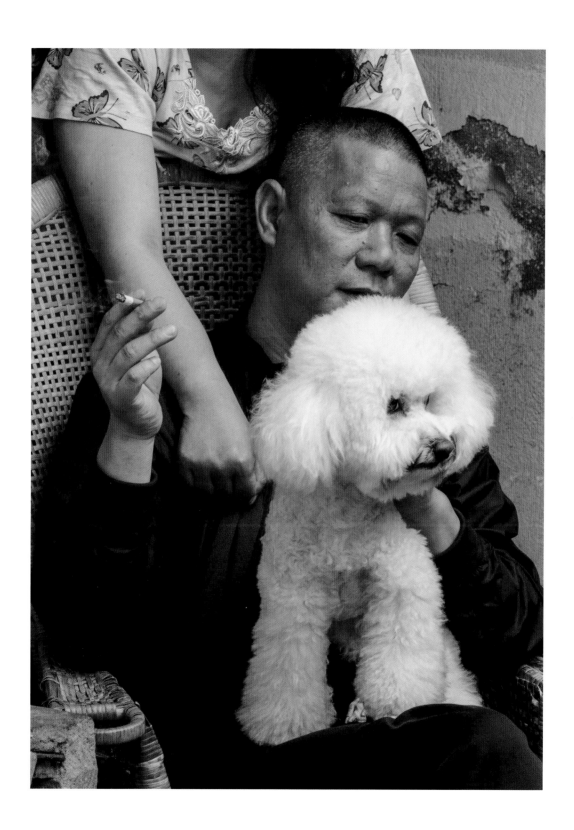

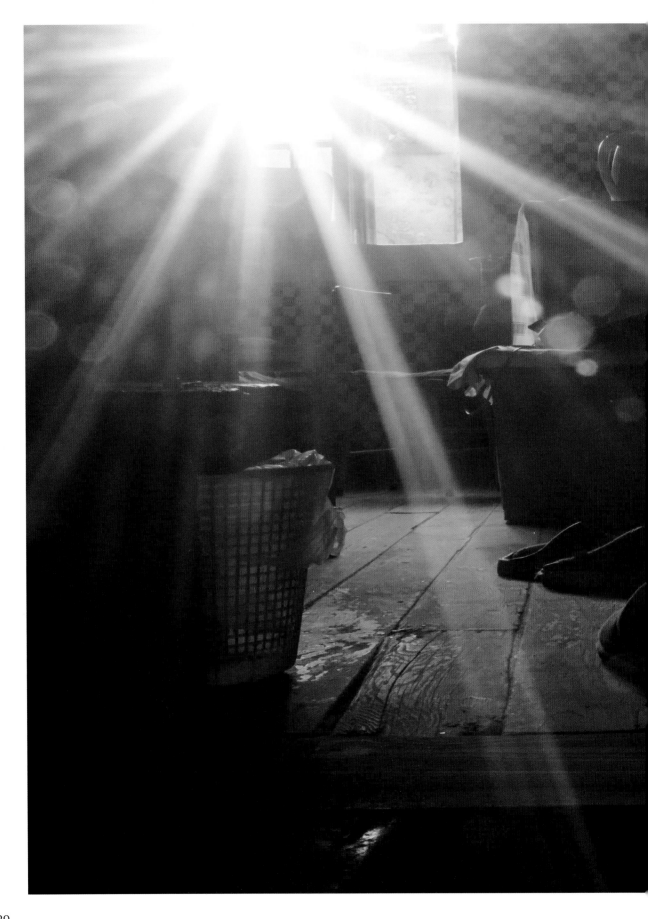

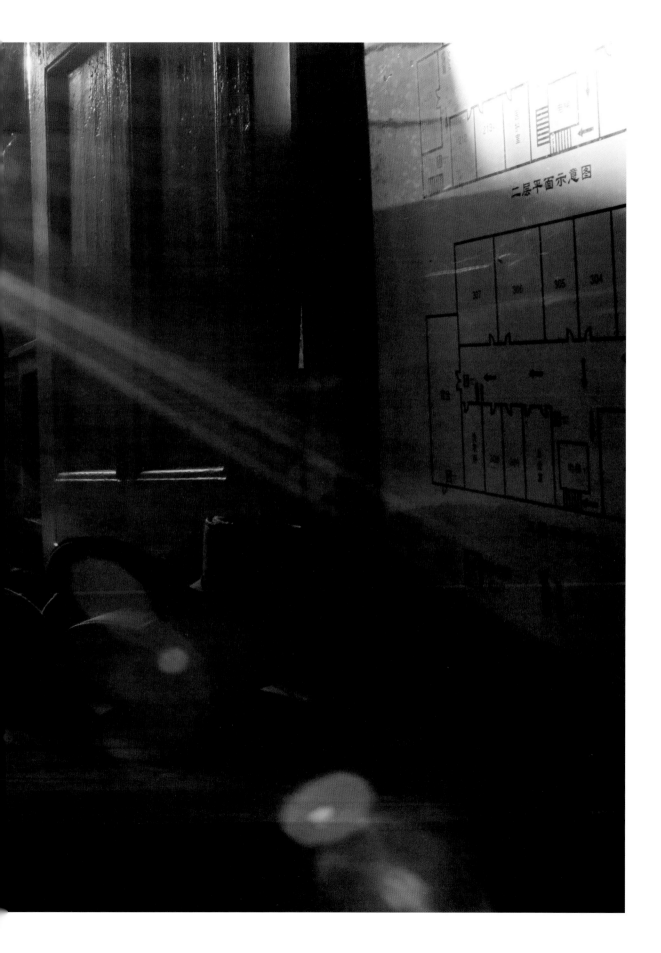

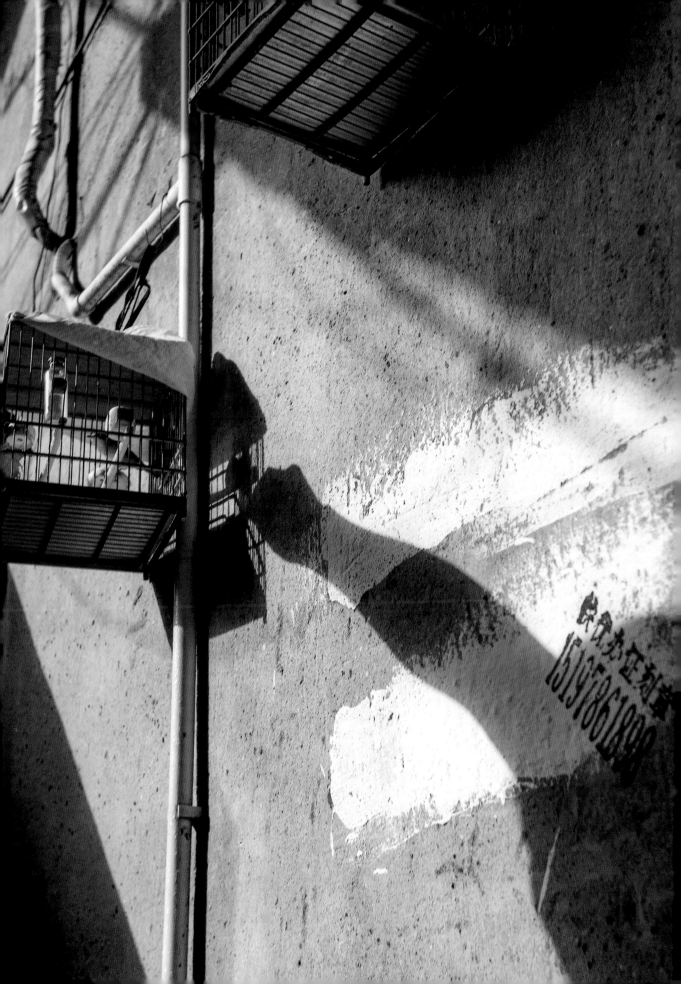

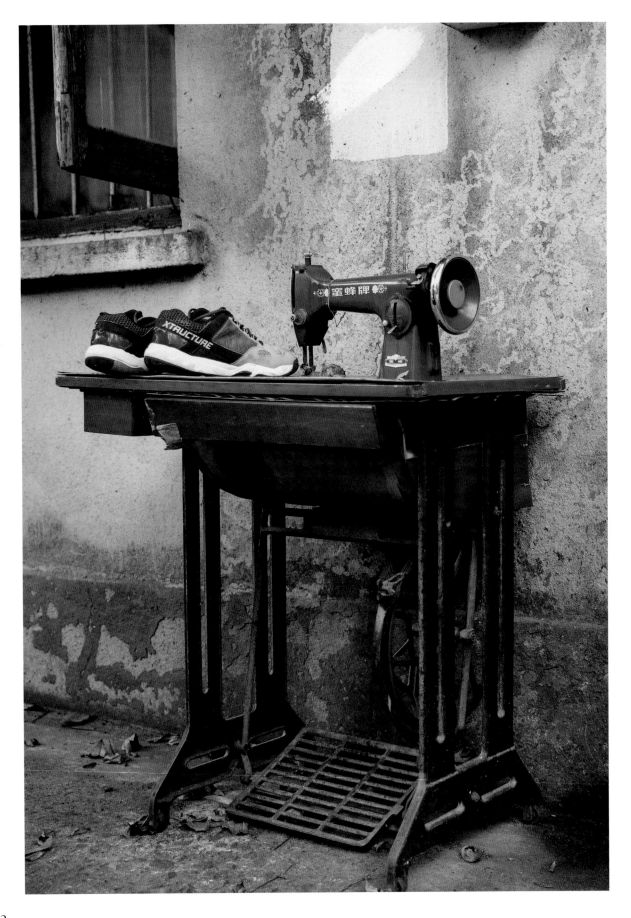

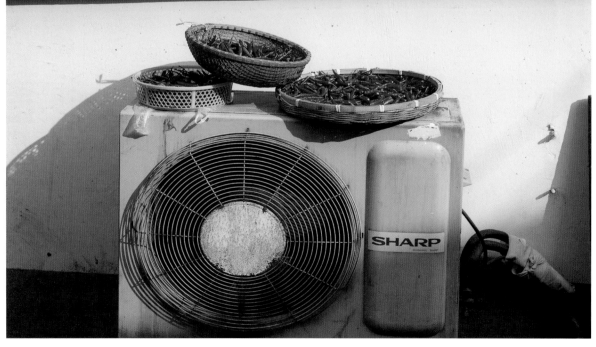

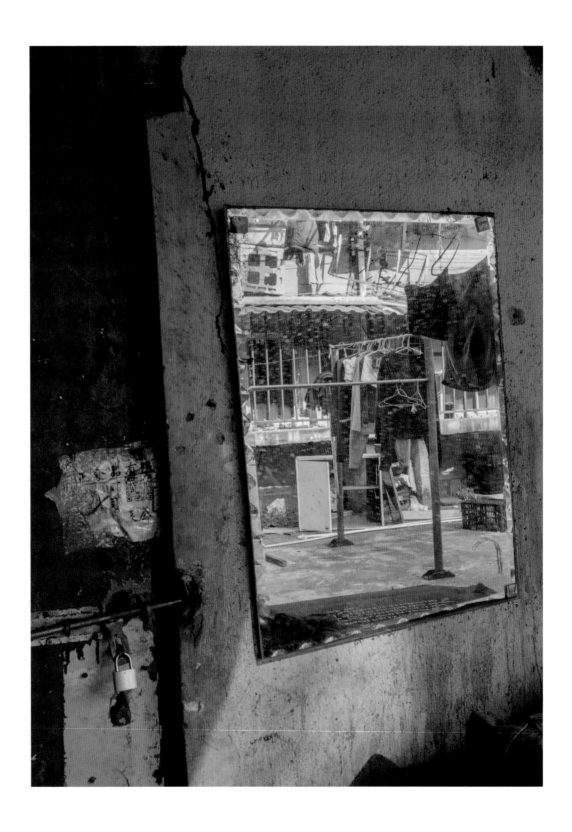

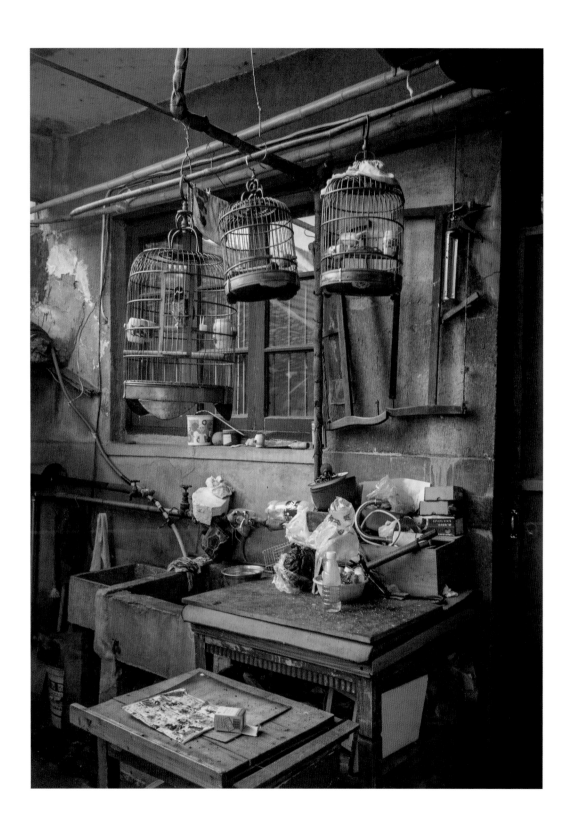

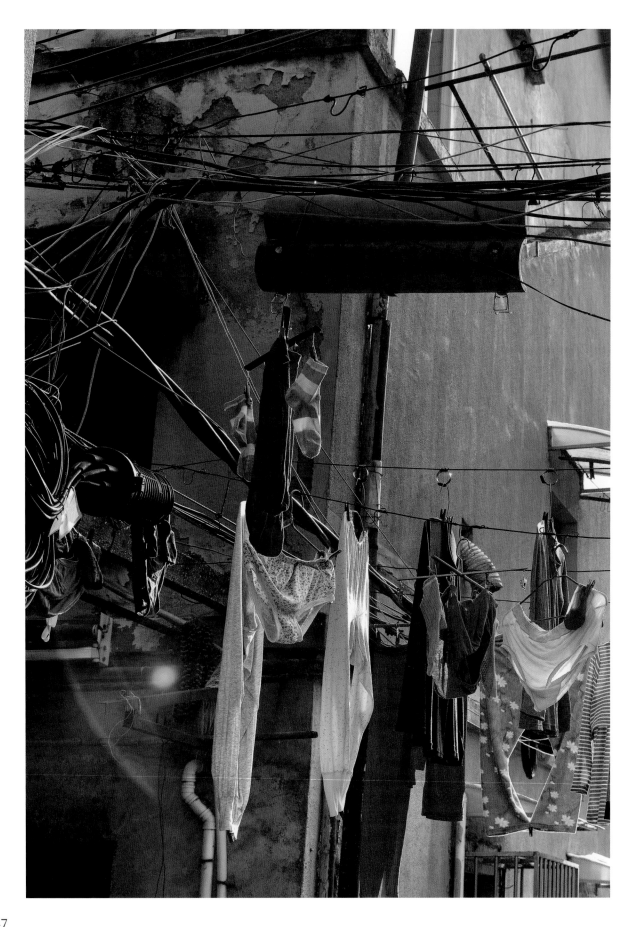

47

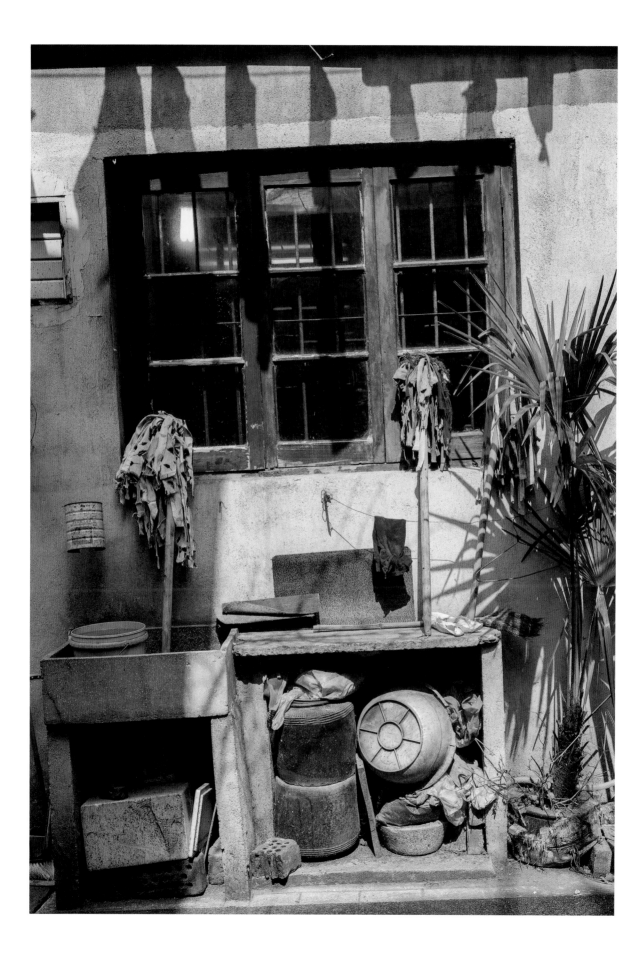

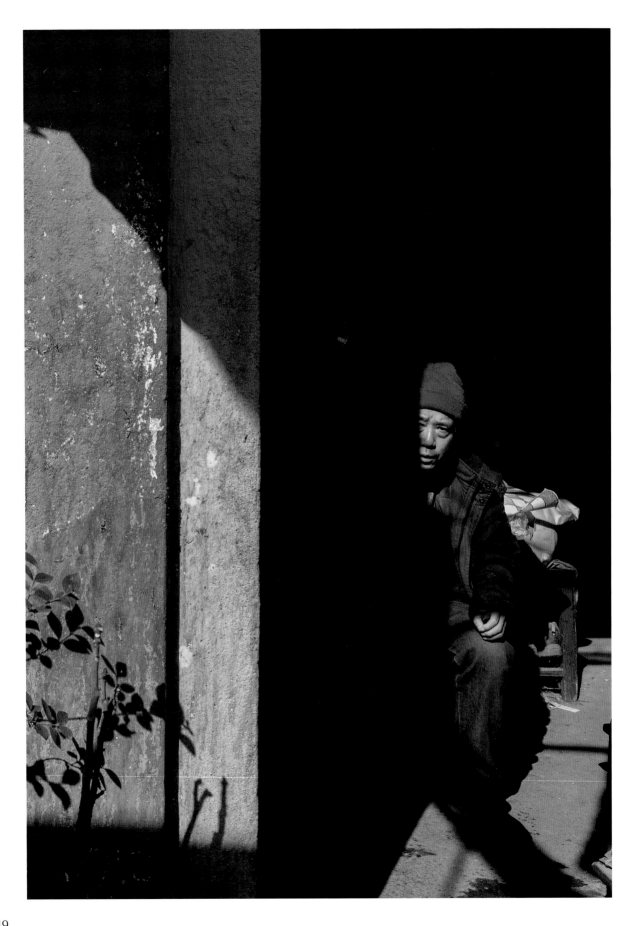

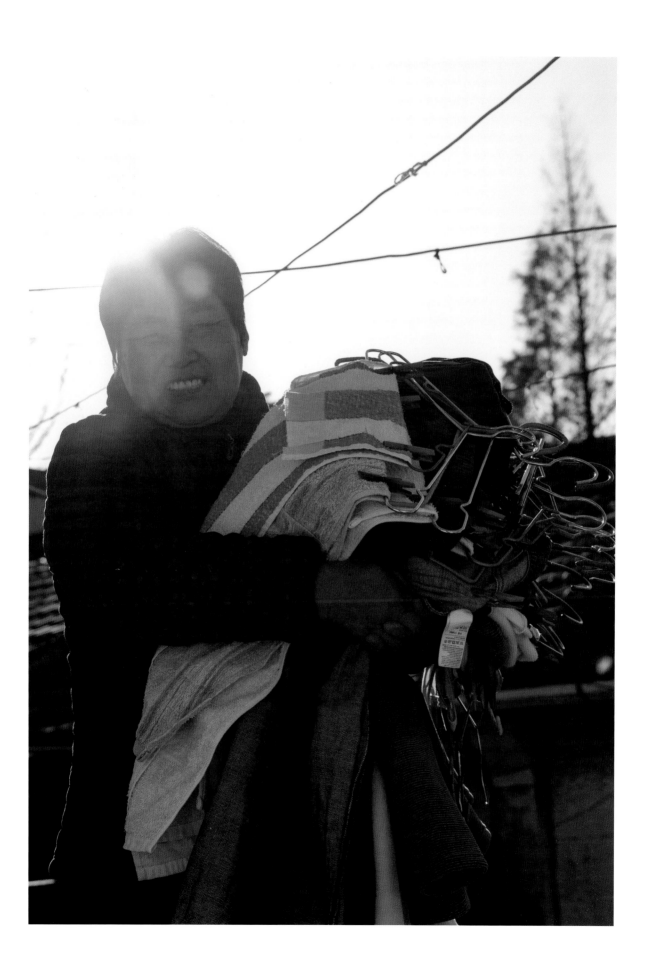

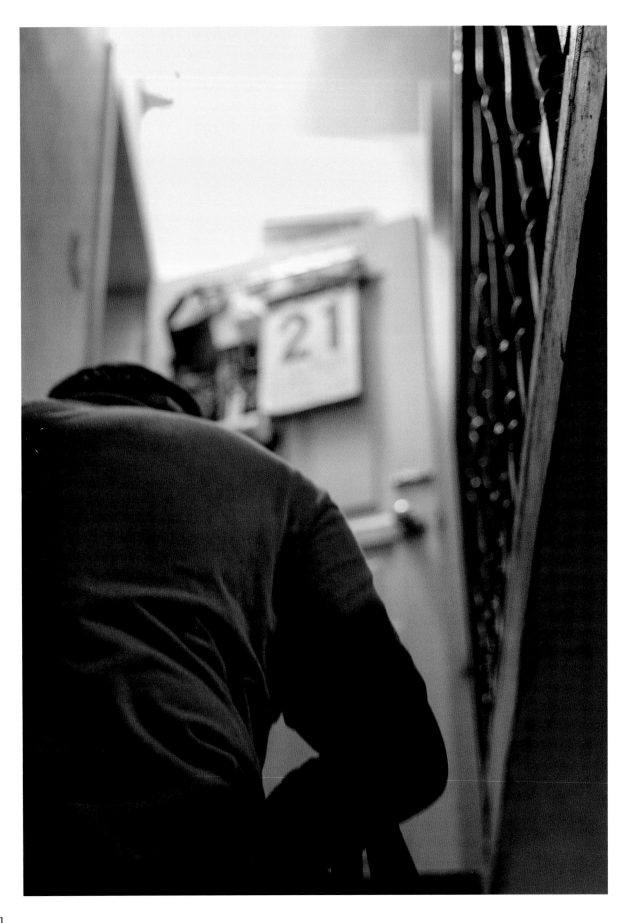

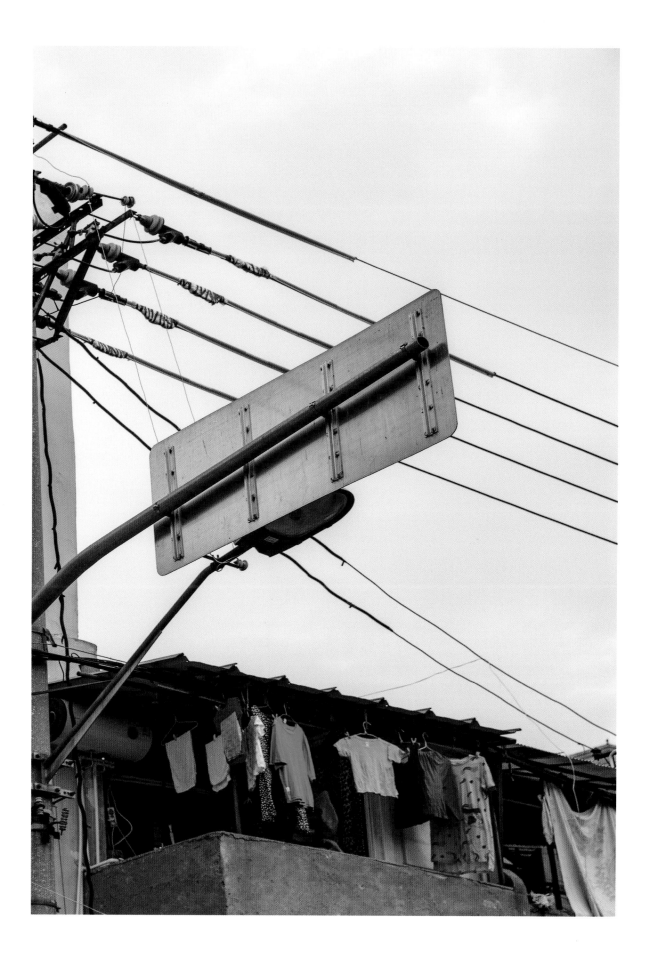

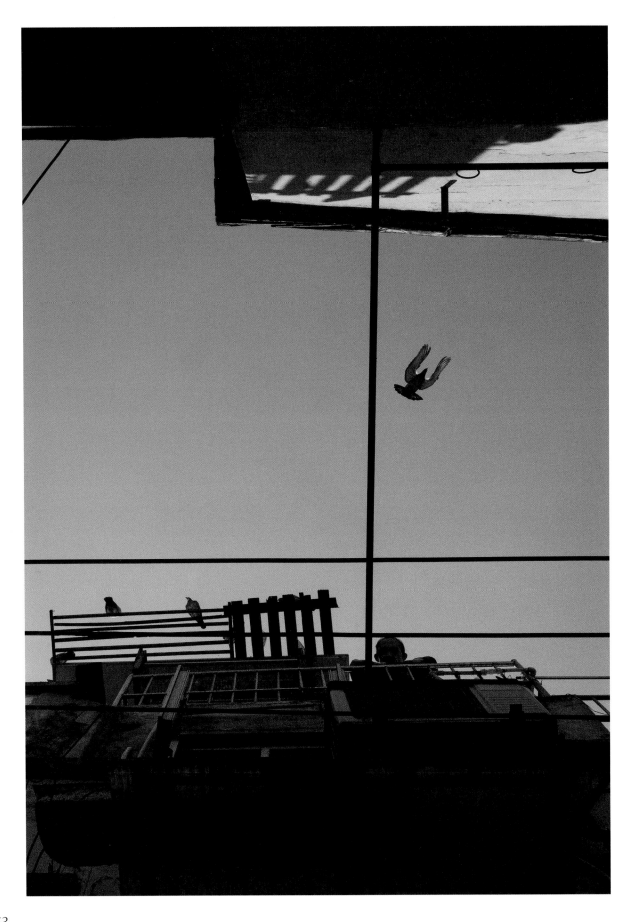

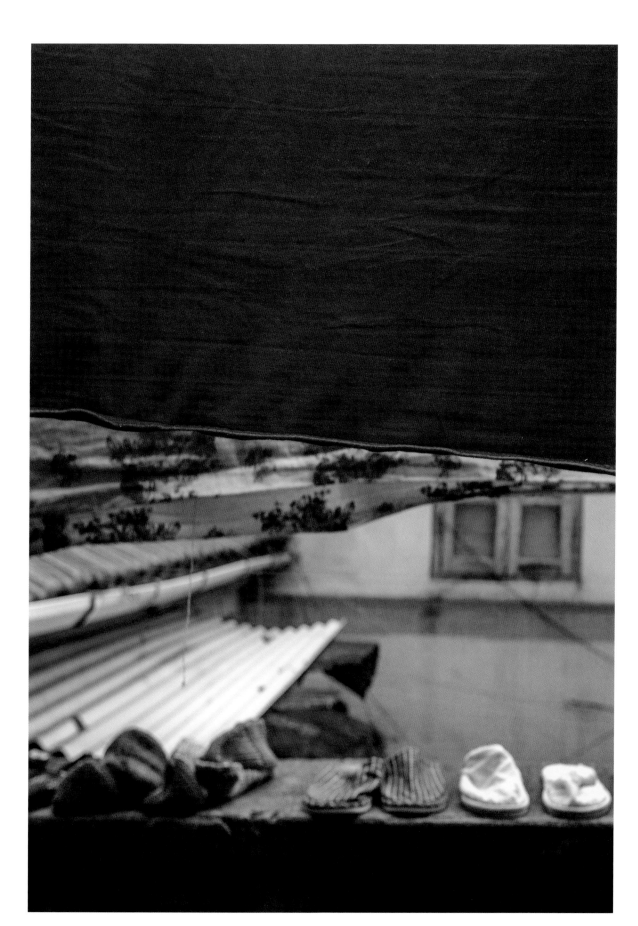

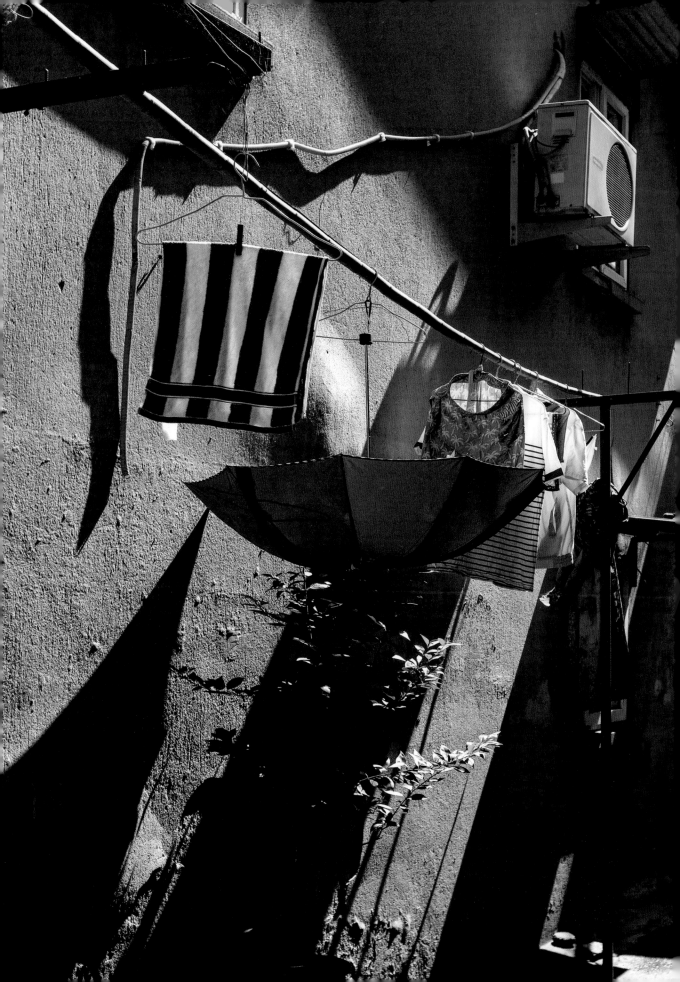

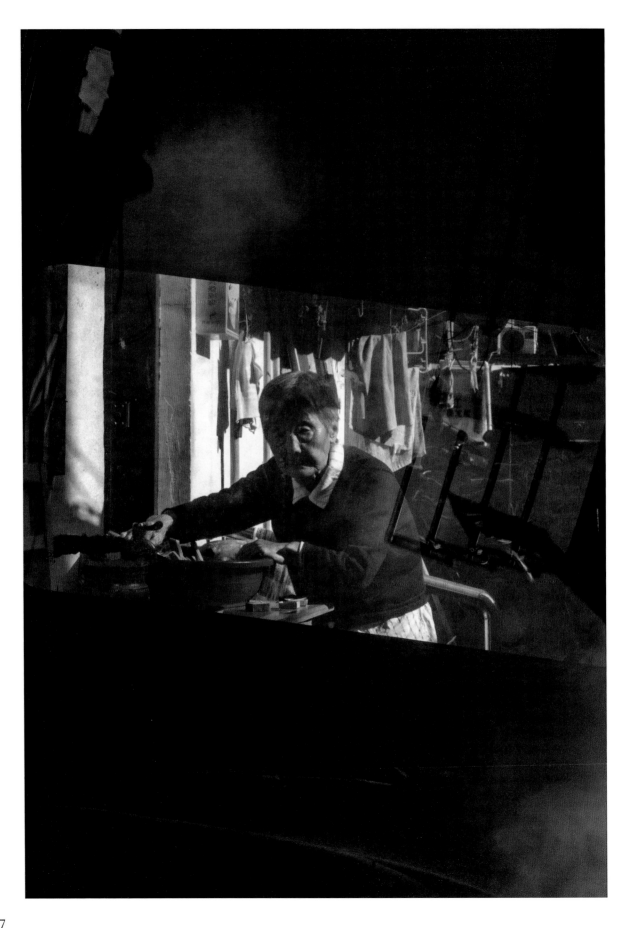

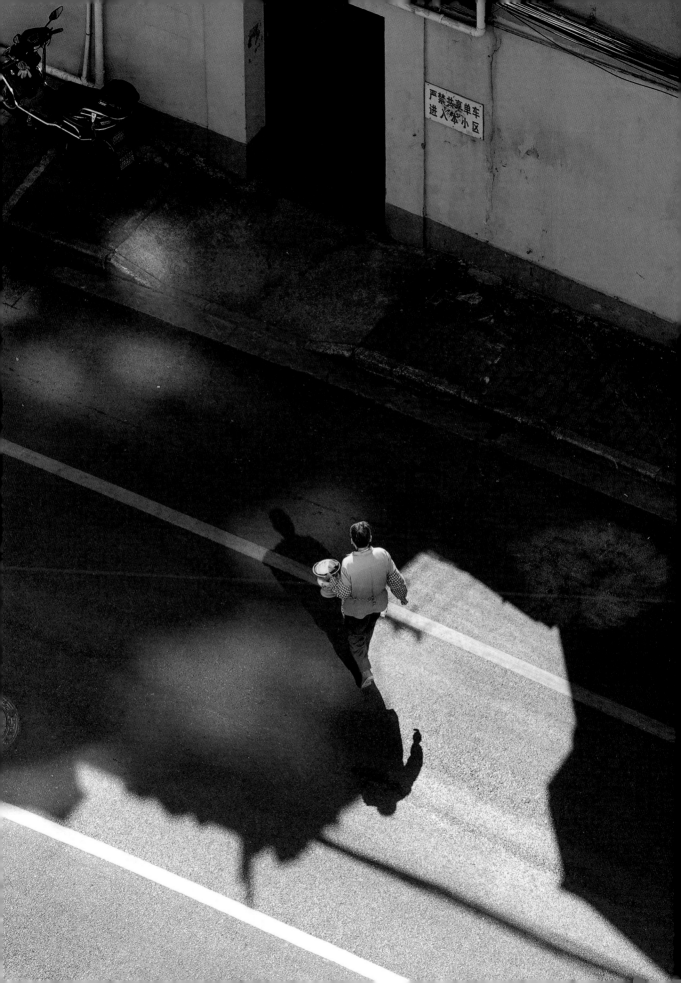

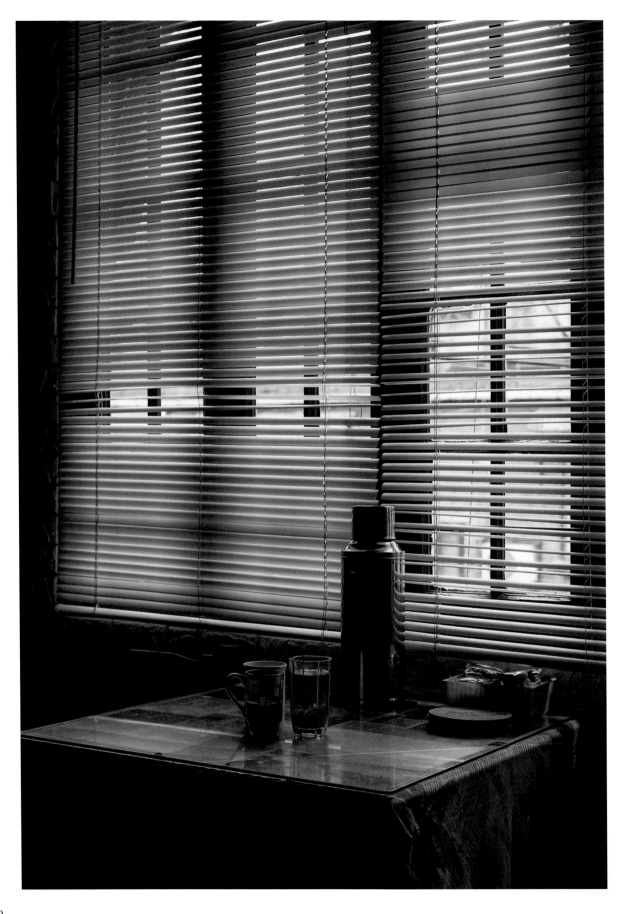

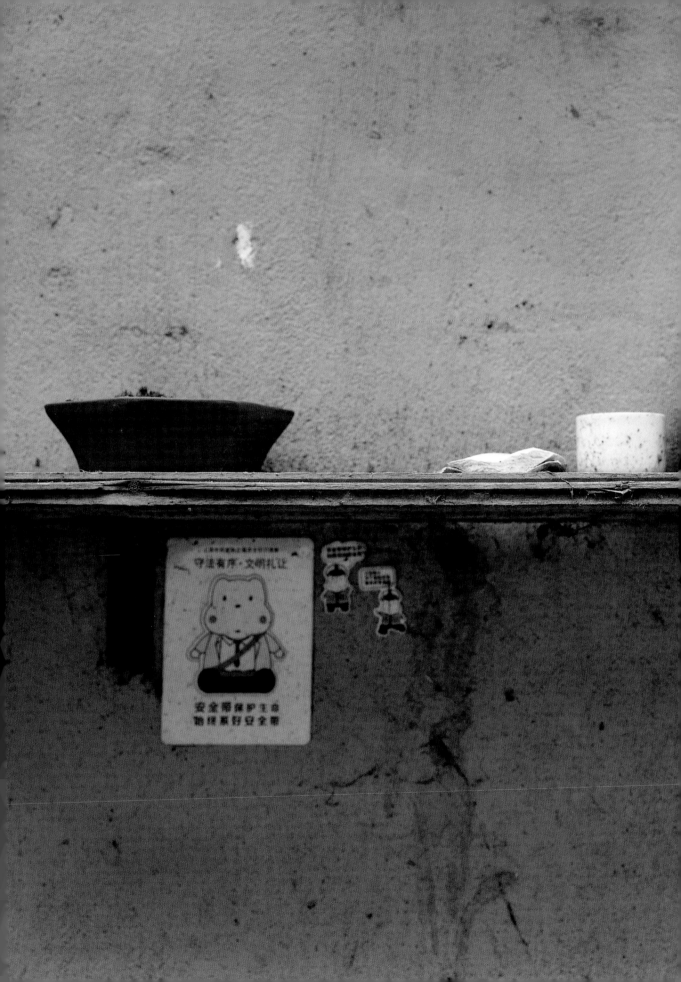

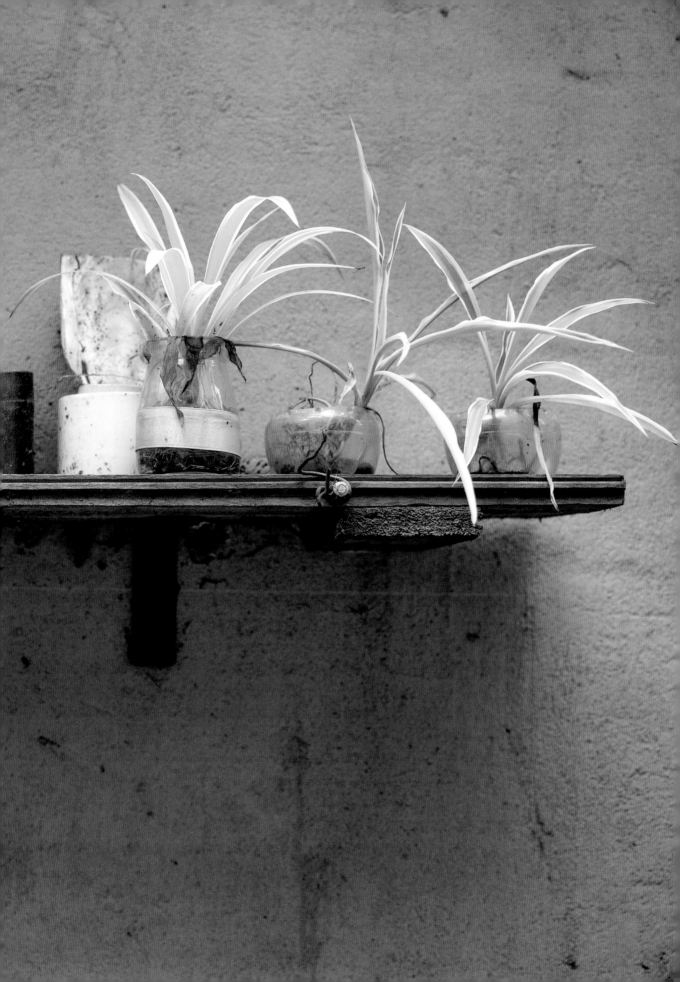

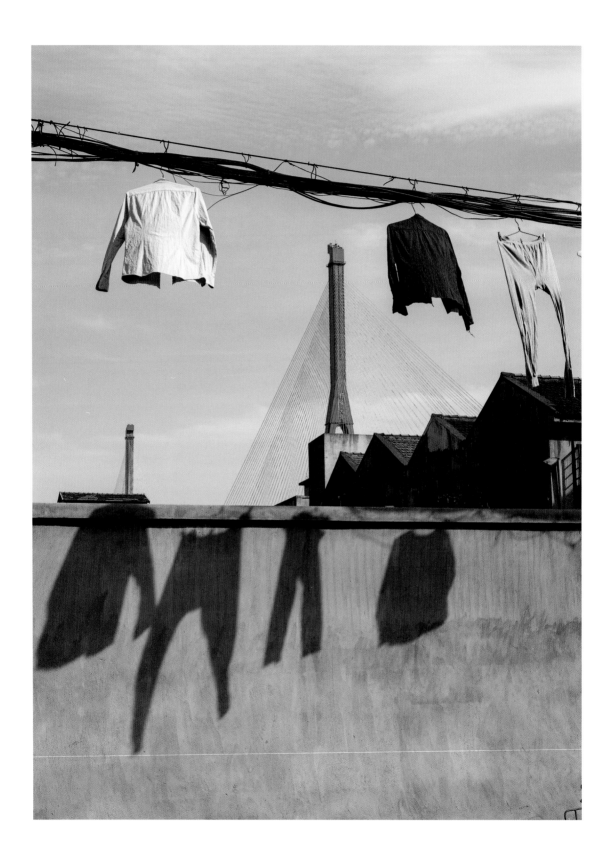

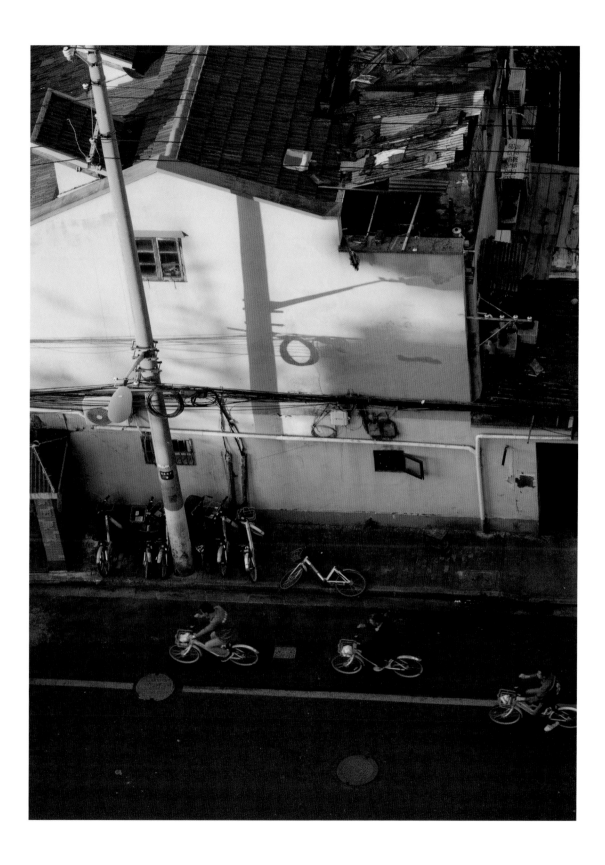

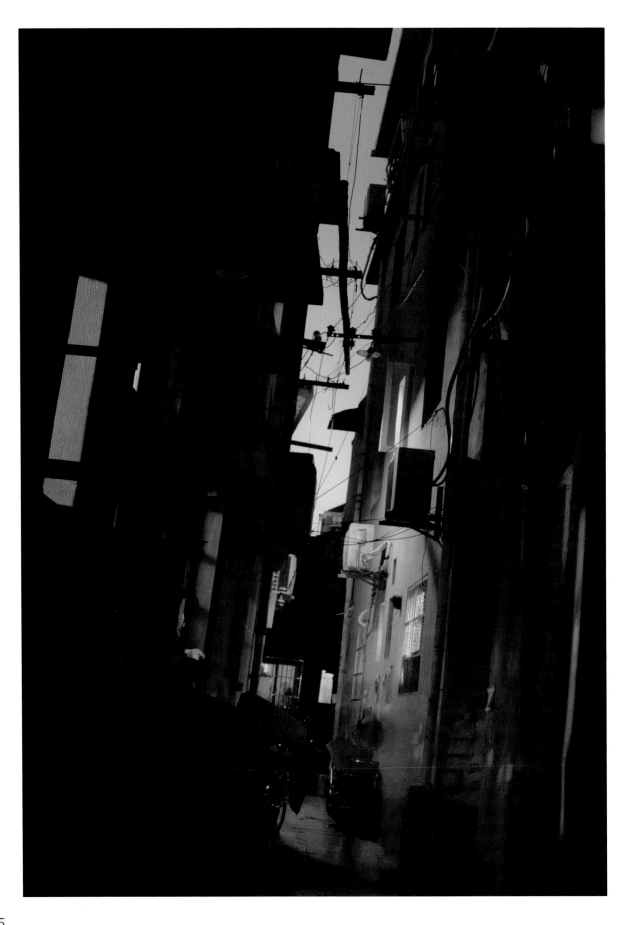

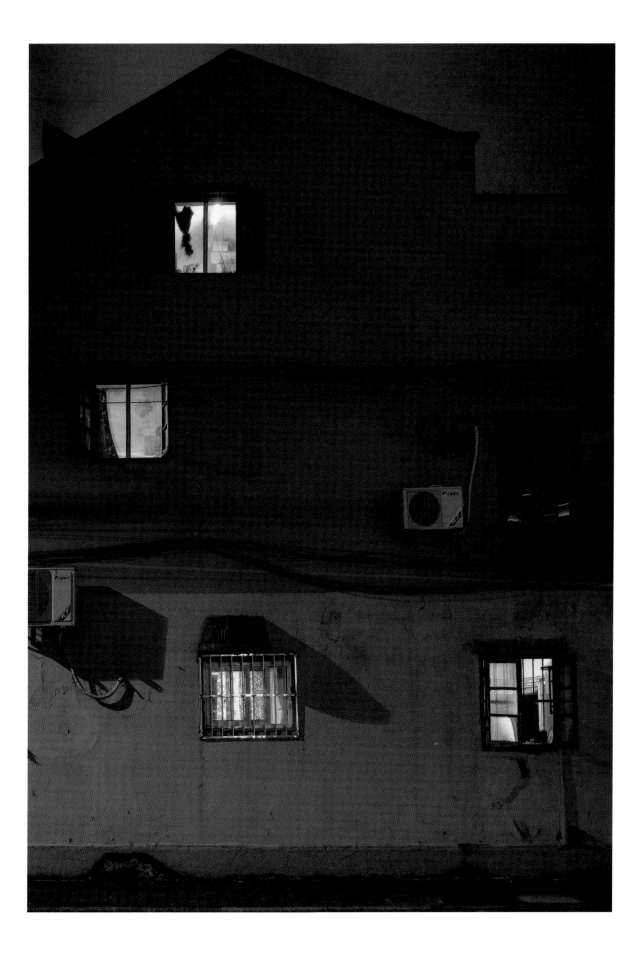

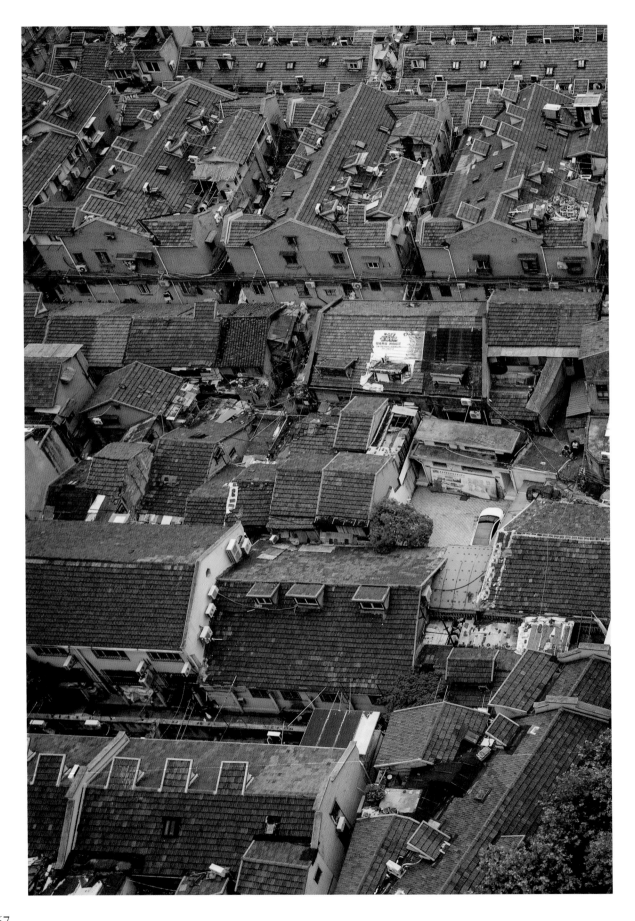

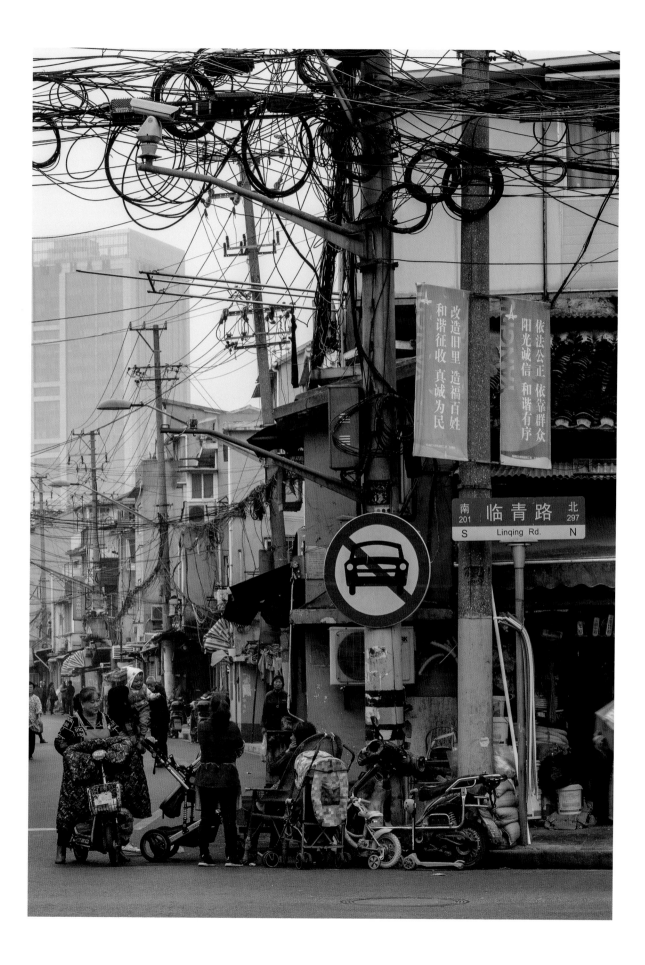

匿光而行

　　本書由感應而生。這感應來自那些漫長而平淡的歲月，那些被人忽略的人與物，聆聽這些寂靜的細語，又豈止是一場視覺之旅。

　　細閱吳建斌的《短歌行》，節奏簡潔，章節明快，內容聚焦於上海老區的斑駁歲月，隱現出庶民生活中的一份厚度及溫度，在整整八十多頁的圖集中，影像的處理手法含蓄而大度，寬廣而不失細膩，內容舖排有如長短句般起伏迴旋，是近年難得的一份佳作。作者自 2017 年起鏡頭聚焦於一個上海即將消逝的老區，他以小觀大，意識到的是一個時間層與及一個歲月的流逝，並制定一個文獻性的紀錄方案。

　　舊區重建計劃是個複雜而浩大的工程。就以巴黎為例，昔日十九世紀的巴黎老區是個人口密集，髒亂不堪，衛生條件極為惡劣的城市。當時的貧民窟遍佈於整個巴黎城市，一個小小房間每每擠擁地住上十多口人，排污系統更是個大問題。直至十九世紀中葉，昔時法國政府痛定思痛，決定對大巴黎這個中古時期的城市重建為現代大都會，作出大手筆改動。這次城市重建項目工程甚為浩大，由當時的塞納省省長喬治 – 歐仁・奧斯曼負責執行，巴黎史上稱為奧斯曼時期，奧斯曼只負責執行了二十年，因群情壓力下被逼下台，但巴黎的重建項目沒有因此停頓下來，而整個重建工程前後接近半世紀。巴黎的新舊交替，亦造就了一位影像詩人的誕生，仁歐阿傑。他的照片有如絮語般的城市民謠，一幀幀如詩般的影像，淨化了這個時代的喧嘩。

《短歌行》的拍攝項目至 2020 年完結，這 4 年間吳建斌風雨不改堅持拍攝，調動了一切可動用的個人時間，但卻不是一帆風順，特別是對於一個即將消逝的社區來說，他需要的是消化所處的景象，從而進入內化，這需要一個過程。開始的時候他以傳統的黑白紀實手法拍攝，粗感質、暗色調，以搶拍快拍的方式著手；但這樣的攝影方式，圖像的視覺落點往往流於偏小狹窄，甚至流於表面，如此繼續下去，連自己也被捆綁起來。吳建斌亦意識到創作處於瓶頸位置，面對這些窘局，創作怎樣向前推進？怎樣擺脫固有觀念的規範？

　　薩依德在其最後隨筆《論晚期風格》中剖釋，即使是偉大的藝術家在創作路途上的成熟風格上亦難免矛盾複雜，當既有的創作經驗去至端末，藝術家每每踏出截然不同的突破。

　　也許，在一道午後斜陽的交鳴閃耀下，吳建斌赫然有所體會，他決定捨棄一如往昔的拍攝思路，讓他的鏡內世界由「攝」轉向「悟」，由外轉向內。他的思緒轉入更廣更深的層面。小區中的四時變化，晝夜的交替，生命的輪轉不息，隱現出日常變化的無限意涵。這次跨越與突破，是一次個人美學的轉向，從傳統紀實轉向詩學文本的敘事方式，這股發自內在的變動，如匿身於光裏潛行而起，讓他所觀所感的世界變得清朗，一股中國文人氣息緩緩浮現，於光影間蘊含生機。

<div style="text-align:right">

秦偉

策展人

</div>

Behind the light

Written with impulses from the long peaceful days, the book is not only a visual journey. There are unheard dialogues, between man and objects, softly whispering.

Reading closely, readers will find Wu Jianbin's *A Ballad*, simplistic and vivacious. The scenes of decaying urban districts in Shanghai tenderly narrate the warm-hearted stories of ordinary citizens. In the 80-page album are extraordinary excellent-pieces lyrically composed, subtle and patrician, capacious without losing their delicacy. Since 2017, the author was attracted to a vanishing old neighbourhood in Shanghai where he set his lens, capturing the finest details in the aspiration to document the passage of time.

Urban renewals have been complex and ambitious projects. Old neighbourhoods of Paris in the 19th century, for example, used to be overcrowded, disease-stricken and chaotic, to an extent that you would see slums all over the city. A tiny flat might accommodate more than a dozen of tenants, not to mention its sewage system. Not until the mid-19th century, the French government had not been so determined to transform the medieval city into a modern metropolis. The then Prefect of Seine, Georges Eugène Haussmann took charge of the massive project for 20 years, the so called Haussmannian period. Despite invoking widespread discontentment and Hausmann stepping down, the renovation lasted for nearly half a century. The metamorphosis gave birth to the great pictorial poet, Eugène Atget, whose photographs compose the turbulent era into poetic images, casting urban folklores.

The entire photo-shooting project of *A Ballad* concluded in 2020. For four years Wu has persisted in photographing despite all adversity. Every second

he could have spared from his personal time, pondering what he saw, followed by a process of internalisation, was necessary for documenting a vanishing community. In the beginning, he took grainy, heavy tone snapshots, following the black–and–white documentary tradition. Such stylistics, nevertheless, narrowed the foci of the photograph which, in some cases, could only arrest superficial images, and hence limited his creativity. Countering such a bottleneck, how did he breakthrough and free his creative work from inherent norms?

Edward Said, in one of his last essays, On Late Style: *Music and Literature Against the Grain*, expounds that great artists having established their styles struggle when their creativity is exhausted and this is the moment they forge ahead and innovate.

Perhaps, flashed by the sunbeam in an afternoon, Wu came to an epiphany. He casted aside his past perceptions on photography. The world was no longer spectated but realised through his lens. He delved into the inner nature of things and his sensations reached further in breadth and in depth — the seasons of year and the times of day in the neighbourhood, revolving restlessly as do our daily lives, are what the photographs subtly guide viewers to contemplate. It is not only a great leap from a documentary to a poetic narrative, but also an aesthetical transcendence of Wu personally. Such an internal drive silently rose, long after hiding itself behind the light. The contours of reality become lucid with the aura of Chinese literati. Between the light and the shadows is his vigorous creativity.

Chun Wai
Curator

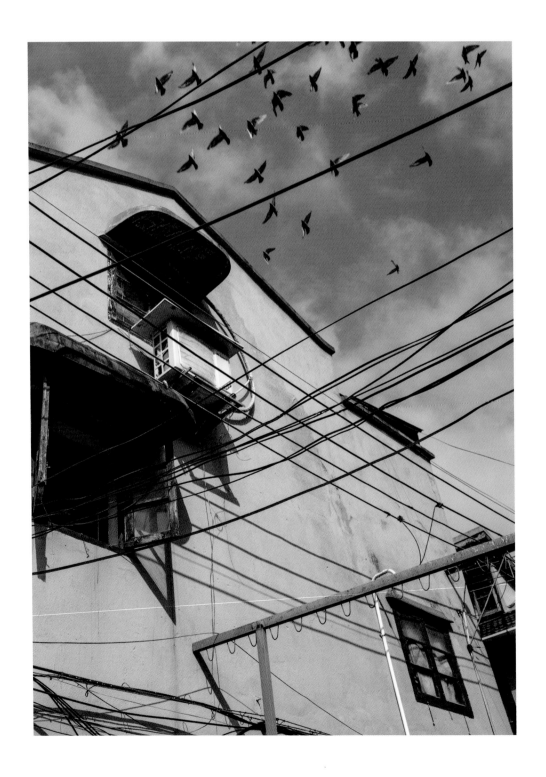

吳建斌簡歷

- 男，1962 年生，陝西渭南人。在香港生活了 30 年。
- 工商管理博士、高級會計師、知名財經專家、西安交大兼職教授、小說作家。
- 自由攝影人、紀實攝影師。有近 30 年的攝影經歷。
- 現為中國攝影家協會會員、企業家攝影協會（深圳）執行主席、中國企業家攝影學會副主席、中國藝術攝影學會理事。
- 出版的攝影專輯有《香港記事》、《香港》、《千年牧道》、《老弄堂裏漫步》。
- 出版的文學作品有《海之子》、《海之龍》、《海之魂》、《老闆迷離》、《博弈》、《心若靜，風奈何》。
- 出版的管理著作有《財務智慧》、《我在碧桂園的 1000 天》、《財務管理的本質》。
- 多幅作品選入法國 la martiniere 出版社出版的《當代的中國》一書。
- 多幅作品選入香港著名攝影家劉香成出版的《上海：一座世界城市的肖像》一書。
- 2010 年獲平遙國際攝影節第十屆當年社會生活紀實類優秀攝影師獎。
- 2012 年獲中國臺北國際攝影節優秀攝影師獎。
- 2021 年獲中國攝影金路攝影師獎。
- 2021 年作品獲選入《中國攝影名家百人百幅作品收藏集》。
- 多年來，舉辦過數十次攝影展覽，獲獎頗豐。

Biography of Wu Jianbin

- Born in 1962, from Weinan, Shanxi, Wu has lived in Hong Kong for 30 years.
- Doctor of Business Administration, Senior accountant, Finance specialist, Adjunct professor at Xi'an Jiaotong University, Novelist.
- Independent photographer with over 30 years of experience, specialized in documentary photography.
- Member, China Photographer Association. Executive chair, Entrepreneur Photographer Association (Shenzhen). Vice chair, The Entrepreneurs Photography Society of China. Board member, China Artistic Photography Society.
- Publications (Photography): *An Adversaria of Hong Kong, Faces of Hong Kong, Centuries-Old Herding Passage, Strolling in old longtangs.*
- Publications (Literature): *Hai Zhi Zi, Hai Zhi Long, Hai Zhi Hun, The myth of the boss, Game, Internal Tranquillity.*
- Publications (Business management): *Financial wisdom, 1000 days in Country Garden, The essence of financial management.*
- Photographs selected and published in *China Now* by la martiniere Publishing.
- Photographs selected and published in Liu Xiangcheng's *Shanghai: Portrait of a World City*.
- Received the Top Photographer (Documentary) Award , in the 10th Pingyao International Photography Festival in 2010.
- Received the Excellent Photographer Award in the Taipei Photo in 2012.
- Received the Golden Road Photographer Award in 2021.
- Wu's photograph selected in *100 Pictures of 100 famous photographer's image collection* in 2021.
- Over the years, Wu held a few dozens of photography exhibitions and received numerous awards.

本圖集是配合吳建斌在 5A1 藝術空間舉辦之攝影個展《短歌行》而編製的作品結集
This album is published for Wu Jianbin's solo exhibition *A Ballad* at 5A1 Art Space.

藝術總監 / 策展人：秦偉
Art Director / Curator：Chun Wai

藝術家：吳建斌
Artist：Wu Jianbin

編輯：何寶珊
Editor：Ho Po Shan

翻譯：陳俊熙
Translator: Chan Chun Hay Walter

聯合出版 Co-Published by:
翌藝文舍 PHOTO AT
5A1 藝術空間 5A1 Art Space

展覽主辦單位：5A1 藝術空間，中國深圳
Exhibition Organizer: 5A1 Art Space, Shenzhen, China.

香港出版　2022 年 11 月初版
Published in Hong Kong　First published in November 2022

訂價：　港幣 280 元
Price：　HKD $280

ISBN：　978-988-76514-0-6